IMAGES
of America

BATON ROUGE

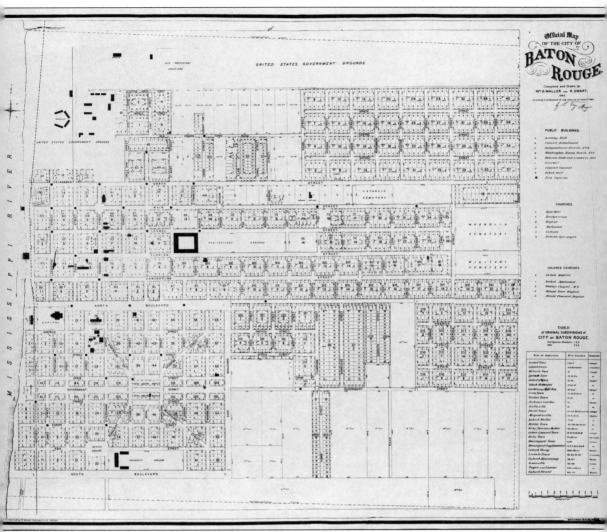

This 1885 map shows many long-lost features of Baton Rouge, including the trolley line; the Asylum for the Deaf, Dumb, and Blind; the state penitentiary; and Louisiana State University's downtown campus. The ferry landing was at the end of Main Street, and the city's wharf was at the foot of Florida Street. (William G. Waller, *Official Map of the City of Baton Rouge*, Courtesy of Louisiana and Lower Mississippi Valley Collections [LLMVC], Louisiana State University [LSU] Libraries.)

ON THE COVER: In 1908, dignitaries at Louisiana State University's downtown campus pose near the first Hill Memorial Library for this picture, taken during the ground-breaking ceremony for the university's Alumni Hall. Builders completed their work on Alumni Hall in two years. Louisiana State University (LSU) moved parts of the building to the new campus in 1926 and incorporated them into the structure that houses the journalism school. (Courtesy of the LSU Photograph Collection RG A5000, University Archives, LSU Libraries.)

IMAGES
of America

BATON ROUGE

Sylvia Frank Rodrigue and Faye Phillips

ARCADIA
PUBLISHING

Published by Arcadia Publishing
Charleston SC, Chicago IL, Portsmouth NH, San Francisco CA

Printed in the United States of America

Library of Congress Catalog Card Number: 2008920519

For all general information contact Arcadia Publishing at:
Telephone 843-853-2070
Fax 843-853-0044
E-mail sales@arcadiapublishing.com
For customer service and orders:
Toll-Free 1-888-313-2665

Visit us on the Internet at www.arcadiapublishing.com

To Baton Rouge photographers, past and present

CONTENTS

ACKNOWLEDGMENTS

The authors gratefully acknowledge the assistance of the staff of the Louisiana State University Libraries' special collections. Judy Bolton has greatly assisted with research, and Gabe Harrell and Gina Costello made much of this work possible through their patience and expertise. We also thank the generous staff of the State Library of Louisiana's Louisiana Section, especially Judy Smith. Additionally, we thank the other librarians, archivists, friends, and agencies who have permitted our use of their photographs in our book.

We extend our grateful appreciation to our friends at the Foundation for Historical Louisiana, whose encouragement and support for our first book, *Historic Baton Rouge: An Illustrated History*, inspired us to continue our work on the city's history.

We appreciate the comments and suggestions made by our editorial readers, Judy Bolton, Jennifer Cargill, Marjorie Frank, Richard Frank, Betsey Pendergast, and Elaine Smyth, and we are grateful for the assistance of Katie Stephens and the rest of the knowledgeable staff at Arcadia.

Finally, many thanks to family and friends who have assisted with their knowledge, listened to needs, and held steady through the past two books. We especially appreciate the helpful advice and unwavering support of John C. Rodrigue. A special thanks is also given to Cecilia Caputo, the young friend who now wants a Louisiana book for children.

INTRODUCTION

The descendants of Native Americans and emigrants from France, Africa, Spain, England, and Germany have all played a part in the growth, vitality, economy, and culture of Baton Rouge, Louisiana's capital city. This book presents the stories of the people of Baton Rouge from all origins and walks of life at work and at leisure, in their sufferings and celebrations, from 1850 to 2005. The photographs show how the city changed over time from its early days as a military outpost through its periods of major growth, including when the town became the state capital, when Standard Oil opened just north of town, when World War II brought new industry to the booming city on the Mississippi River, and when Hurricane Katrina brought a huge influx of newcomers.

In Images of America: *Baton Rouge*, the city's residents tell their stories through the lenses of both professional and amateur photographers, the men and women who provided an important and fascinating visual record. The most notable professional photographers showcased in *Baton Rouge* are Andrew David Lytle (1834–1917), Jasper Gray Ewing (1878–1972), Fonville Winans (1911–1992), and David King Gleason (1930–1992).

Andrew David Lytle photographed the city through the Civil War and its aftermath to the prosperity brought by the 1909 arrival of the Standard Oil Company. He captured the strangeness of war on the home front, showing the poignant expressions of African Americans pressed into wartime service, the wreckage of burned-out homes, and former slaves further dehumanized by being treated as contraband goods. Having lived through the turmoil of war, Lytle found happiness and renewal in the city's celebrations, such as the popular firemen's parades and theater events. Both during the war and afterward, Lytle climbed to the tops of the town's highest buildings to produce early aerial views. The collections of Lytle's surviving photographs contain images of new school buildings, local churches, muddy streets with mule-drawn streetcars, and gatherings of leading citizens. Some of Lytle's last photographs show activities at the thriving downtown campus of Louisiana State University.

Jasper Gray Ewing opened his photography studio in the city around 1917 as raw recruits passed through on troop trains from the training grounds in Alexandria to ships waiting in New Orleans to take them to European battlefields. He documented the growth and prosperity of Baton Rouge after World War I, showing the expansion of "Big Oil," which would dominate the region's economy into the 21st century. Ewing focused his camera on the town's residents and businesses, and on fun times at Louisiana State University. From 1887 until 1926, LSU occupied the area of Baton Rouge that now contains the state capitol and its grounds. During that era, much of the city's life revolved around LSU and the state government, which—next to Standard Oil—employed most of the people in Baton Rouge. Ewing witnessed LSU football and baseball games, cadet formations and pranks, the growth of the campus, the growth of the faculty and their families, and the development of the city around LSU and the capitol. Ewing turned his eye toward the city's challenges, too, and photographed the harsh times of the Great Flood of 1927, the Great Depression, and World War II.

Young photographer Fonville Winans, who became known to his many customers and fans simply as Fonville, began his work here during the Depression. Winans settled in Baton Rouge around 1940 after having spent an exciting decade photographing and filming life in the southernmost part of Louisiana. Throughout his career as a photographic artist, Winans was always in demand. Many stories are told about his reckless exploits, particularly of his solo flights in a small plane, leaning out the window to take pictures. Because of his daring, Winans captured unique aerial views of snow on the capitol and ice in the Mississippi River during the severe winter of 1940. Winans's photographs of governors Huey Long, Earl Long, and Richard Leche give a vivid portrayal of these men, showing the personalities of these famous—and infamous—leaders of Louisiana. He continued the documentation of Louisiana State University begun by Jasper Ewing, taking formal and informal pictures of LSU people and activities, including sports, social events, and students at rest and play. Winans enjoyed taking highly posed photographs of students around or in the various campus buildings, thus featuring both the university's coeds and its architecture. As Baton Rouge's favorite society photographer, Winans held a uniquely powerful say over the timing of marriages in the city: during the prosperous decades after World War II, true Baton Rouge debutantes scheduled their wedding ceremonies around Winans's schedule so that he could photograph them.

In the 1960s, Baton Rouge's own David King Gleason started his career as a creative photographer. He became known for his beautiful color images of plantation homes and his stunning aerial views. Gleason, Winans, and others, such as A. E. Woolley, captured the pains caused by the unrest of the civil rights era at local swimming pools, on the campuses of Louisiana State University and Southern University, at downtown establishments, and at the state capitol. Gleason gained work and acclaim for his commercial photography of Baton Rouge businesses and chemical plants along the river. He, like Winans, also became a notable wedding photographer. Gleason documented the beauty of the city's parks, festivals, university campuses, and such passing events as the final days of baptisms in the Mississippi River. Gleason and Winans shared a mutual love of aerial photography, and they took most of the aerial views of Baton Rouge that appear in this volume.

In addition to these four prominent photographers, many others have also made valuable contributions to the visual record of the city, including Civil War photographers W. D. McPherson and a Mr. Oliver, and the photographers who worked for the city's newspapers. These visual artists have left a priceless treasure for the people of Baton Rouge, a record of past achievements, amusements, successes, and failures to interest and inspire.

One

1850–1865

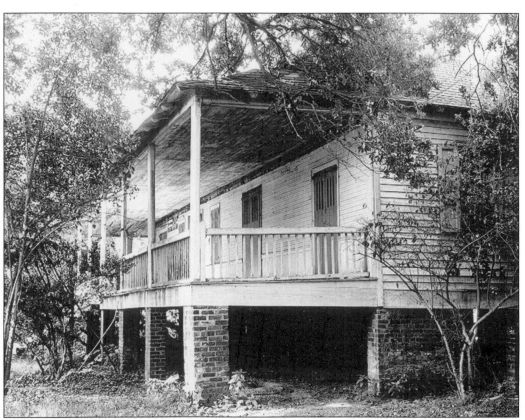

Planter John Joyce originally built this house at Magnolia Mound around 1790, and he died eight years later. His widow, Constance Rochon Joyce, and her second husband, Armand Duplantier, made renovations in the early 1800s. Shown in the 1970s before its restoration, the plantation home opened its doors to the public as a historic house museum in 1981. (Courtesy of the Louisiana Department of Culture, Recreation, and Tourism.)

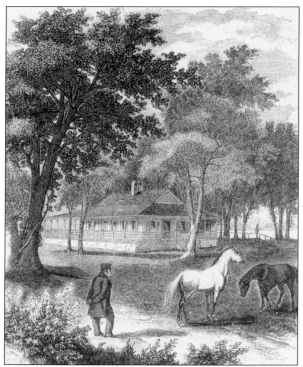

In the early 1820s, Zachary Taylor supervised the building of Baton Rouge's Pentagon Barracks. He lived in this two-story, Acadian-style house, which had been built for the Spanish commandant during the colonial era. From here, Taylor set off on a daring raid that started the Mexican War, and he later became the 12th president of the United States. (*Harper's New Monthly Magazine*, November 1854, courtesy of LLMVC, LSU Libraries.)

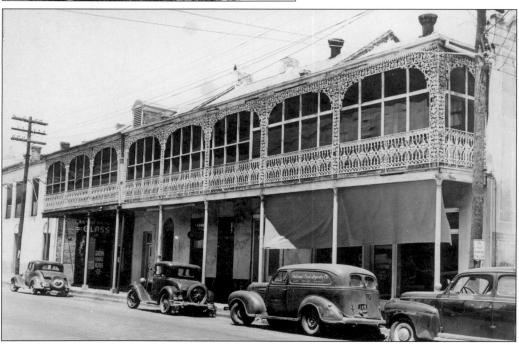

Baton Rouge attorney Charles R. Tessier, who served as parish judge for about 30 years, built these three attached structures individually in the early to mid-19th century. They are among the oldest buildings in the city and represent a style that was common here in its day. Located on Lafayette Street, the Tessier buildings are also known as the Lafayette buildings. (Courtesy of the Charles East Papers, LLMVC, LSU Libraries.)

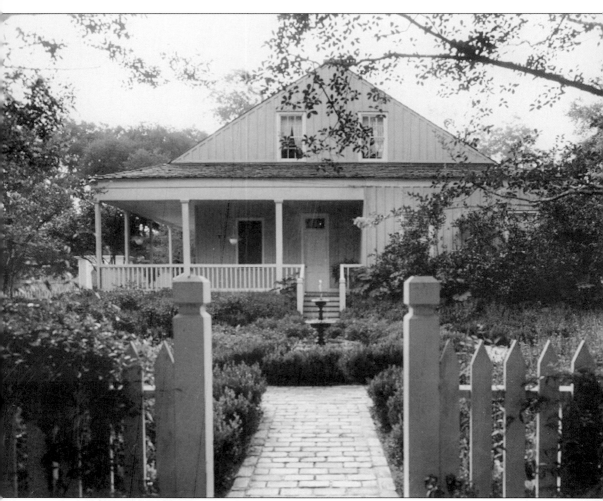

Built in 1817 from local cypress wood, the Mount Hope plantation house is a typical 19th-century Greek Revival home. Its original owners, the Sharps, came to Louisiana with other Germans who moved from the mid-Atlantic region (likely Hagerstown, Maryland) in the 18th century. The group tried to live in a low-lying area, but its frequent flooding forced them to seek new land. They settled permanently on elevated ground just south of Baton Rouge. The area was called the "Dutch Highlands," a corruption of the word *Deutsch*, meaning "German." The Sharp family obtained a land grant from the Spanish governor for 400 acres on Highland Road, which ran through the Dutch Highlands, and Paul Joseph Sharp and his son, Joseph, built Mount Hope. The Sharps and their neighbors in the Dutch Highlands—the Kleinpeters, the Garigs, and others—planted indigo, then cotton, and then sugar cane. Shown in the 1970s, Mount Hope is the only remaining plantation home from the Dutch Highlands area of Baton Rouge. (Courtesy of the Louisiana Department of Culture, Recreation, and Tourism.)

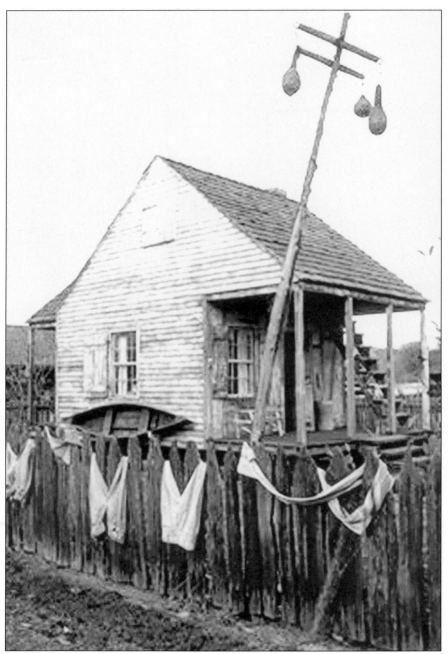

Another early form of architecture in south Louisiana, the Acadian cabin shows a combination of French, Canadian, and Creole influences. The front porch, or gallery, usually opened into two rooms on the inside, and the cabin was usually two rooms deep. An unusual feature is the outside stairway, shown at the right side of this cabin, which led to a sleeping loft in the attic. Insulation consisted of bousillage, a mixture of mud and Spanish moss. These small buildings sat a few feet off the ground for protection against flooding and for increased air circulation. This reproduction Acadian cabin, with clothes drying on the fence outside, is part of the folk architecture section of the Rural Life Museum in Baton Rouge. The 450-acre museum opened in 1976 off Essen Lane. (Courtesy of the Louisiana Department of Culture, Recreation, and Tourism.)

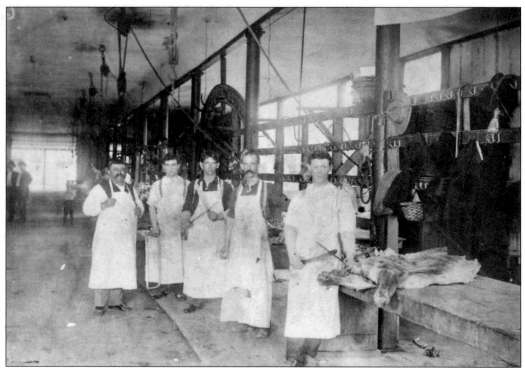

In 1859, these five unidentified butchers (pictured above) pose with the tools of their trade, large knives and knife sharpeners. Signs of the butchers' work—large slabs of meat—are visible on the table behind them. Their workspace was inside the Baton Rouge Market, the town's central location for purchases of food and dried goods. Fire destroyed the original market—along with one-fifth of the town—in 1849, and this brick building replaced it on the same spot, near the rebuilt brick courthouse. In the photograph at right, one of the butchers stands behind three young boys, likely apprentice butchers, in the same location. This angle shows other men and women at work in the background and visiting in the market's doorway. (Both courtesy of the Collection of Mrs. Julie Kennedy, State Library of Louisiana.)

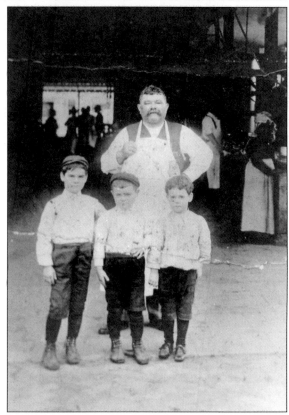

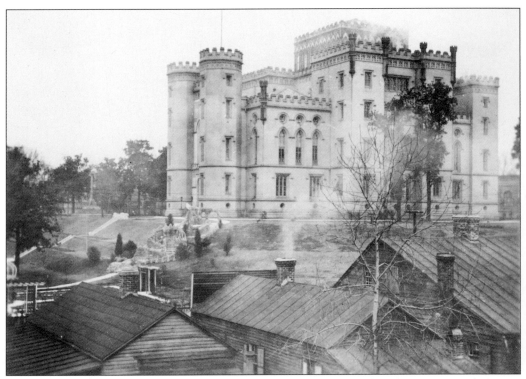

The Louisiana legislature incorporated Baton Rouge in 1817 and made it the state capital 29 years later. Shown here from the south side around 1924, this original statehouse opened in 1850, though construction continued for two more years. After 1932, when Huey Long built the new capitol, this storied structure became known as the Old State Capitol. (Courtesy of the Col. Joseph S. Tate Album, LLMVC, LSU Libraries.)

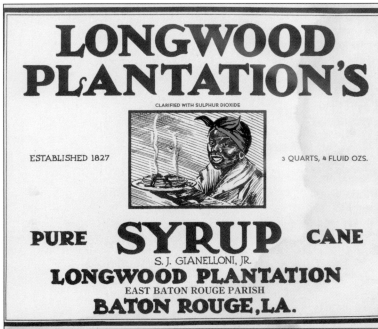

Slaves working on nearby fertile farmland produced mostly sugar, as indicated by this label from Longwood Plantation, eight miles south of town. In town, enslaved men and women worked as cooks, nurses, bakers, and painters, among a variety of other jobs. Baton Rouge's population in 1850 totaled 3,905; about 28 percent were slaves. (Courtesy of Sabin J. Gianelloni Sr. Papers, LLMVC, LSU Libraries.)

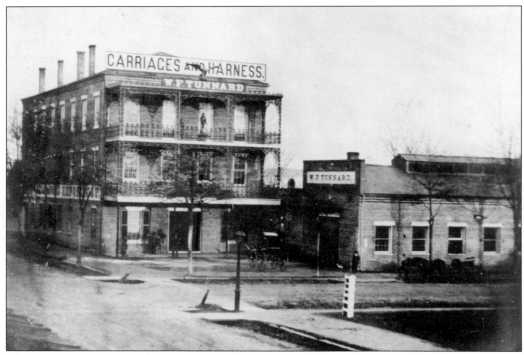

This rare 1855 ambrotype shows William F. Tunnard's Carriage and Harness Factory at the corner of Main and Church Streets. Tunnard built the best carriages in the region, as well as buggies, wagons for plantation use, carts, harnesses, and iron goods. In 1861, he closed the factory, and he and his sons volunteered to fight for the Confederacy. (Courtesy of the LLMVC, LSU Libraries.)

In 1866, Confederate major William H. Tunnard, William F. Tunnard's son, published *A Southern Record: The History of the Third Regiment Louisiana Infantry*, the story of his unit's wartime experiences in the Civil War's western theater. His book includes descriptions of wartime Baton Rouge. (From *A Southern Record*, courtesy of the LLMVC, LSU Libraries.)

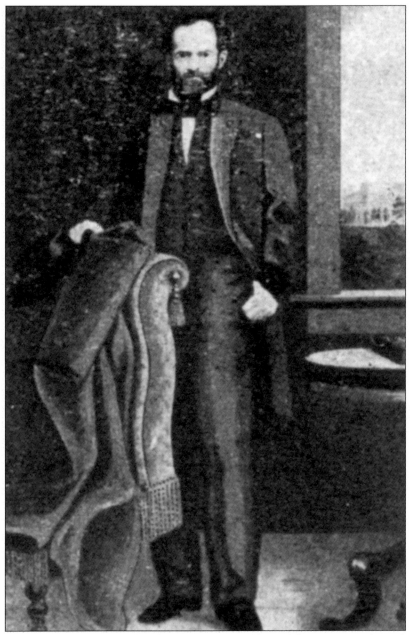

William Tecumseh Sherman served as the first superintendent of the Louisiana State Seminary of Learning and Military Academy (later Louisiana State University); he started classes on January 2, 1860. At the time, the seminary was located in Pineville, Louisiana, three miles from Alexandria, and it can be seen in the background of this portrait. When the state's military seized the federal arsenal at Baton Rouge in early 1861, Sherman resigned his post, leaving his beloved school, and headed north to serve the Union cause. Sherman went on to win international fame for his 1864 March to the Sea and other military successes. In 1869, he became commanding general of the U.S. Army. Despite Sherman's love for the South and his importance to LSU, not a single building at the flagship university in Baton Rouge has been named after him. (Courtesy of the LSU Photograph Collection, RG A5000, University Archives, LSU Libraries.)

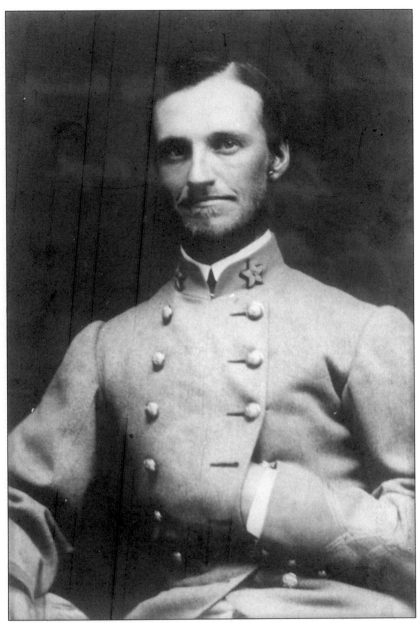

In the 1850s, David French Boyd attended the University of Virginia and then moved to Louisiana to teach school. During the year before secession and the outbreak of the Civil War, he taught ancient languages and English literature at the Louisiana State Seminary of Learning and Military Academy. After his friend William T. Sherman left Louisiana to offer his services to the Union, Boyd joined the Confederate army. During his wartime service, Boyd rose from the rank of private to major. Jayhawkers captured him early in 1864 and sold him to the Union army, which imprisoned him in Natchez. At Boyd's request, Sherman moved him to a prison in New Orleans, and he was released later that year. At the end of the Civil War, Boyd returned to Louisiana and became LSU's second president. With determination and savvy political ability, he rebuilt and expanded the school. Boyd and Sherman remained lifelong friends. (Courtesy of the LSU Photograph Collection, RG A5000, University Archives, LSU Libraries.)

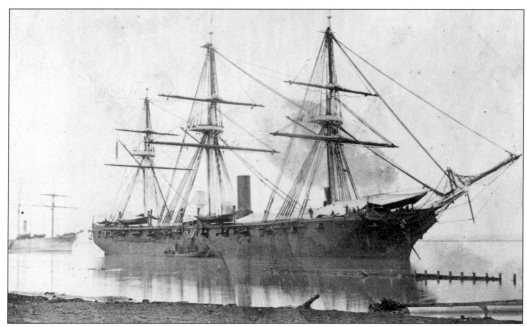

The USS *Richmond*, a wooden steam sloop first launched in January 1860, helped to capture Baton Rouge for the Union as part of a fleet led by David Farragut in May 1862. This beautiful ship held more than 250 men and carried 22 guns, including one 80-pound Dahlgren smoothbore. (Courtesy of the G. H. Suydam Collection, LLMVC, LSU Libraries.)

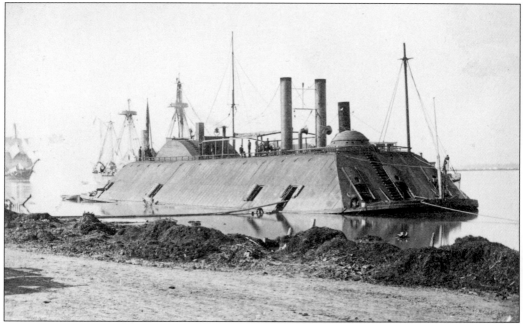

This 1,000-ton ironclad river gunboat, the USS *Essex*, was built in 1856 as a steam ferry. Its commander, William D. Porter, oversaw its upgrade to an ironclad. The ship helped fight off the attacking Confederate army during the August 5, 1862, battle of Baton Rouge. The Confederates were nearly successful, but a twist of fate caused their retreat. (Courtesy of the G. H. Suydam Collection, LLMVC, LSU Libraries.)

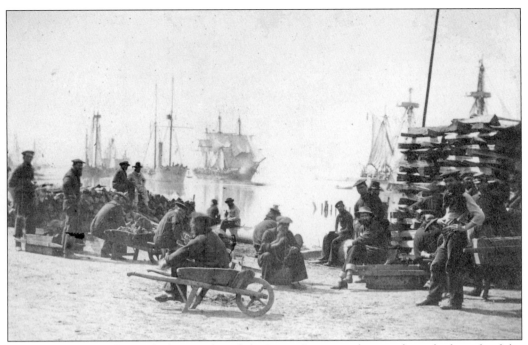

Many of Farragut's ships relied on coal, and the Baton Rouge coaling yard supplied much of the fleet's fuel. Here coal heavers from the *Essex* rest on the river's edge. The USS *Richmond* is in the center of the picture, with the USS *Winona* to its left and the USS *Mississippi* to its right, behind the pile of wood. (Courtesy of the G. H. Suydam Collection, LLMVC, LSU Libraries.)

This photograph, representative of the destruction wrought during the Civil War, shows a group of people standing by a bombed-out home in Baton Rouge. Not only did Federal gunboats like the *Essex* damage the town, but the victorious Union soldiers also burned one third of the buildings in Baton Rouge to clear land and thus aid their defenses. (Courtesy of the Andrew D. Lytle Collection, LLMVC, LSU Libraries.)

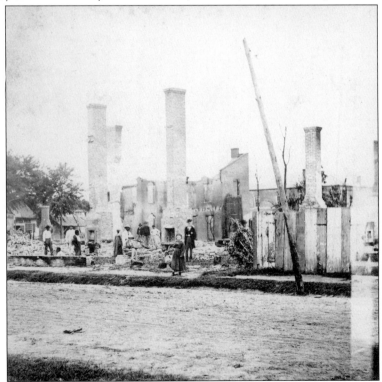

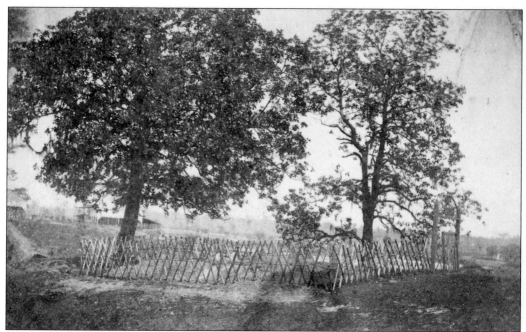

The U.S. Army interred its war dead at this cemetery off North Street after the August battle. Casualties from the 25th Connecticut Volunteers were buried in the section shown in this photograph. In 1867, the government officially designated it as the Baton Rouge National Cemetery. (Courtesy of the Marshall Dunham Photograph Album, LLMVC, LSU Libraries.)

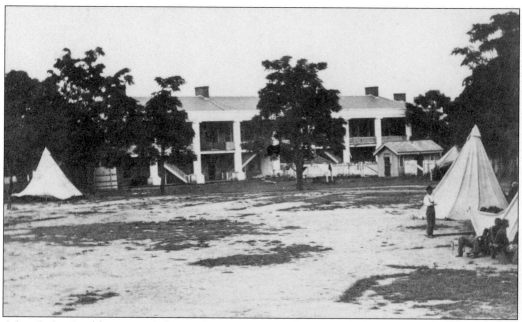

After Federal soldiers retook Baton Rouge and buried their dead, they pitched their tents and camped in various spots around the town. Some Union soldiers set up the tents shown here on the grounds of the four-sided Pentagon Barracks, close to the Mississippi River. (Courtesy of the Marshall Dunham Photograph Album, LLMVC, LSU Libraries.)

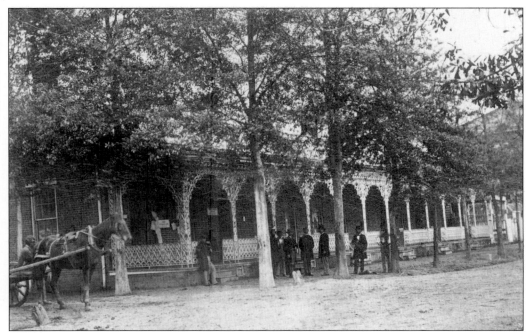

The federal provost marshal office made its headquarters on Pike's Row, on the north side of Florida Street near the corner of Third Street. This photograph was taken by W. D. McPherson and his then-partner, one Mr. Oliver (whose first name is not known), who printed their photographs in Baton Rouge starting in the spring of 1863. (Courtesy of the G. H. Suydam Collection, LLMVC, LSU Libraries.)

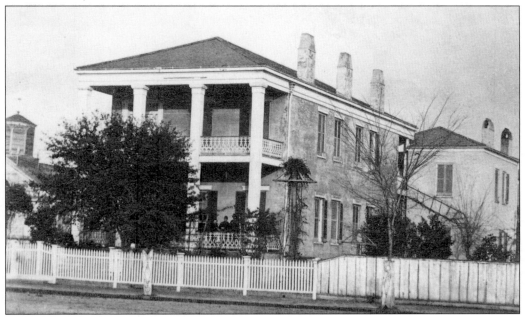

McPherson and Oliver also took this image of the home of Baton Rouge banker and fireman Samuel M. Hart. Union colonel Nathan A. M. Dudley used this building at the corner of North and Church Streets as his military headquarters. (Courtesy of the G. H. Suydam Collection, LLMVC, LSU Libraries.)

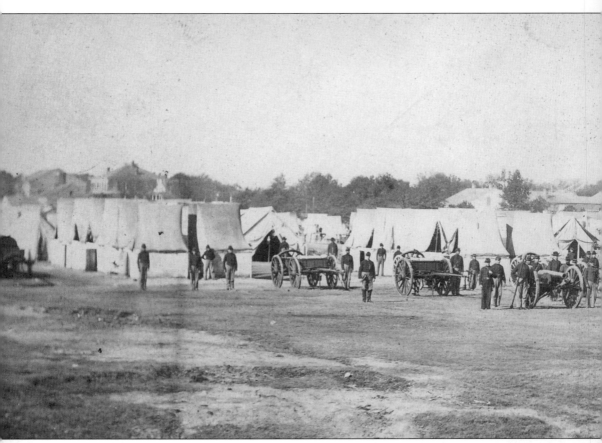

Residents of Baton Rouge found it very disconcerting, to say the least, for their town to be overrun with Federal soldiers. In addition to camping at the Pentagon Barracks, arsenal grounds, and in the capitol, Union soldiers also set up tents at the Louisiana State Penitentiary. This 1862 Lytle photograph shows the 1st Wisconsin Battery in a somewhat muddy field just south of the

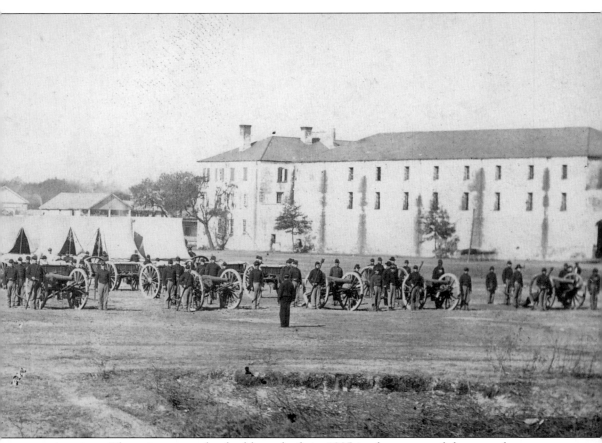

penitentiary. The prison complex had been built in 1835 in the center of the town between Florida and Laurel Streets and Seventh and Twelfth Streets. The state eventually moved the prison from Baton Rouge to Angola Farm, just west of St. Francisville. (Courtesy of the Andrew D. Lytle Collection, LLMVC, LSU Libraries.)

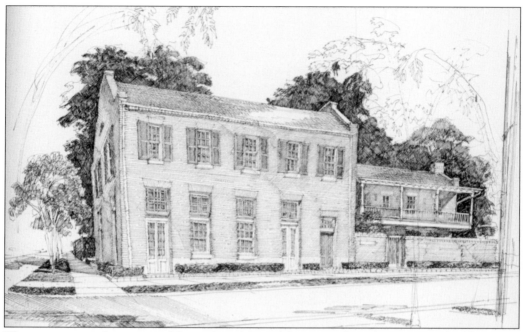

This structure at the corner of Seventh and Laurel Streets is the sole remaining building from the Louisiana State Penitentiary at Baton Rouge. The prison warden used it as his home, and the house also contained the prison store. (Sketch by John Desmond, published in *Louisiana's Antebellum Architecture*, Baton Rouge: Claitor's Publishing Division, 1970.)

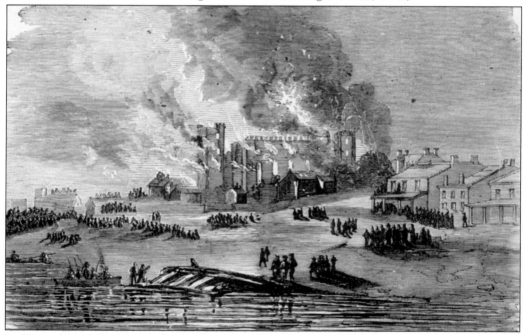

In December 1862, a raging fire broke out in the state capitol building, destroying much of its interior. The Union army had been camped there at the time, and official reports blamed the fire on the condition of the capitol's chimney. (*Frank Leslie's Illustrated Famous Leaders and Battle Scenes of the Civil War*, edited by Louis Shepheard Moat, 1896, courtesy of the Library of Congress.)

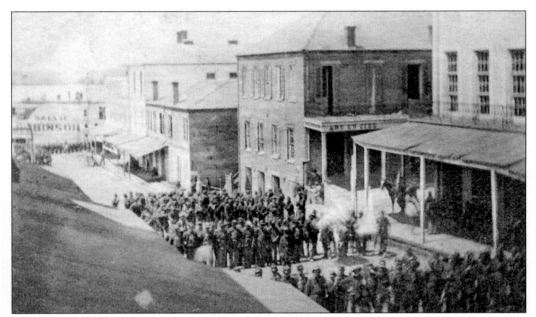

These U.S. troops stand in formation on Main Street at the corner of Lafayette Street. The side-wheel steamboat *Sallie Robinson*, at left, traveled between the ports of Baton Rouge and New Orleans in 1863. The Harney House Hotel, built in the 1840s, is shown at the extreme right. (Courtesy of the U.S. Military History Institute, Carlisle Barracks, Pennsylvania.)

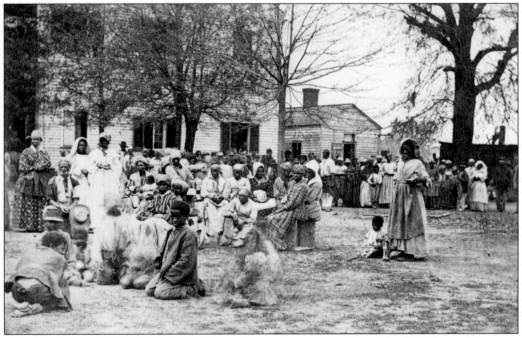

This former seminary for girls in Baton Rouge became a temporary home for the African American families (shown here) who had fled slavery when the Union army neared the plantations on which they had lived and worked. Slaves who left their masters during the Civil War were termed contraband, and this area was called a contraband camp. (Courtesy of the G. H. Suydam Collection, LLMVC, LSU Libraries.)

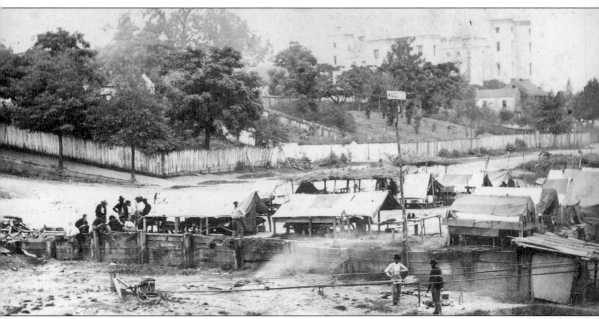

Regaining control of Baton Rouge after the battle, the Federal army sought to fortify its position in the city. Officers pressed local black men into service as general laborers. These men and their shelters are shown on the west side of Front Street between the street and the river. The state capitol is visible in the background. After the August 1862 battle in Baton Rouge, U.S. soldiers remained in the town, stationed at the Pentagon Barracks, for another 15 years. The 1863 Emancipation Proclamation opened the door to freedom, military service, and eventually full citizenship for African Americans. Despite the election of two black Baton Rouge men to the state's constitutional convention in 1867, political control reverted to the same white Democrats who had run the town before Reconstruction. The African American soldiers in the U.S. Colored Troops stationed in Baton Rouge during and after the war endured a hostile racial atmosphere, as did local freedmen and freedwomen. (Courtesy of the Andrew D. Lytle Collection, LLMVC, LSU Libraries.)

Two

CHURCHES AND SCHOOLS

Into the late 1960s, local African American churches still held baptisms in the Mississippi River, as documented here by accomplished photographer David King Gleason. Those about to be baptized wore white. The participants in this baptism ceremony were not identified. (Courtesy of the David King Gleason Papers and Photographs, LLMVC, LSU Libraries.)

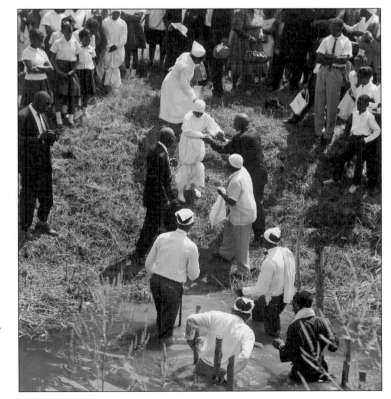

The First Baptist Church, established in 1874 and originally occupying a building on Florida Street, now has two locations in Baton Rouge: at Fifth and Convention Streets, shown here, and at 10478 Perkins Road. This house of worship, shown in a photograph by Art Kleiner, opened in 1955 and stands adjacent to the 1920 church. (Courtesy of the State Library of Louisiana.)

The Bethel African Methodist Church, shown here at 1356 South Boulevard in 1947, belongs to a Wesleyan denomination founded in the early 1800s from the desire of African Americans to have the freedom to form and run their own congregations. Rev. George Gordon established the Bethel church in 1867. (Courtesy of the State Library of Louisiana.)

Fr. John Cambiaso designed St. Joseph's Catholic Church, which was built at the corner of North Street and Church Street (now Fourth Street) in 1855. The congregation dates its founding to 1792. This statue of the Madonna and Christ child sits on the grounds of the handsome, Gothic-style cathedral. (Courtesy of the State Library of Louisiana.)

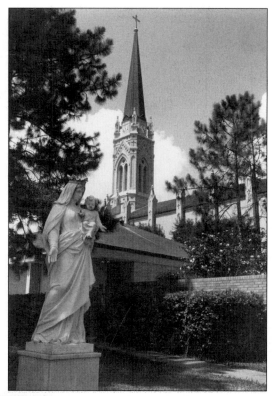

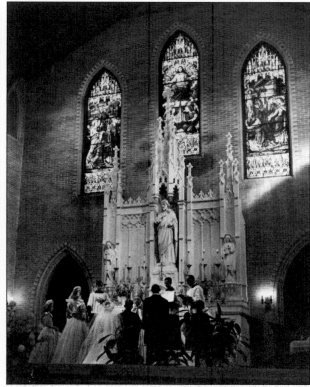

Fonville Winans, a noted Louisiana photographer, took this image of an unidentified wedding party at the altar at St. Joseph's Cathedral in 1953. From the late 1940s until the 1980s, Winans was the most popular wedding photographer in Baton Rouge. The altar was changed during the church's interior remodeling in 1970. (Courtesy of the State Library of Louisiana.)

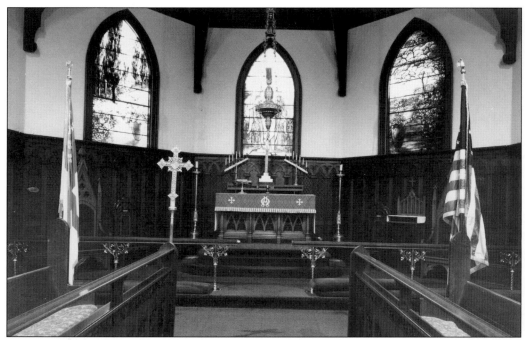

In 1820, the state legislature chartered both St. Joseph's Catholic Church and St. James Episcopal Church. This view of the St. James church, built in 1895 by architect William L. Stevens on Church Street (now Fourth Street), was taken in the 1960s. The Tiffany windows were installed behind the altar in 1910. (Courtesy of the State Library of Louisiana.)

Located at the corner of Fifth and Laurel Streets, this building first housed the Brothers of the Christians School in 1869. In 1877, it became the home of the Hebrew Congregation of Baton Rouge, later named Congregation B'Nai Israel, which was founded in 1858. A new building on Kleinert Avenue replaced this synagogue in 1954. (Courtesy of the Andrew D. Lytle Collection, LLMVC, LSU Libraries.)

The Reverend C. K. Marshall built the original First Methodist Church, the building at right with a steeple, at the corner of Church and Florida Streets in 1834. The image at right was taken by McPherson and Oliver around 1863. To the church's right is the Queyrouze family home; to its left is the Washington Fire Company and, beyond that, St. Joseph's Cathedral. The 1920s postcard below shows many of the same buildings that appear at right: Church Street (now Fourth Street) and St. Joseph's Academy, the First Methodist Church, and St. Joseph's Cathedral. (Right courtesy of the G. H. Suydam Collection, LLMVC, LSU Libraries; below courtesy of the Leroy S. Boyd Papers, Postcard Album, LLMVC, LSU Libraries.)

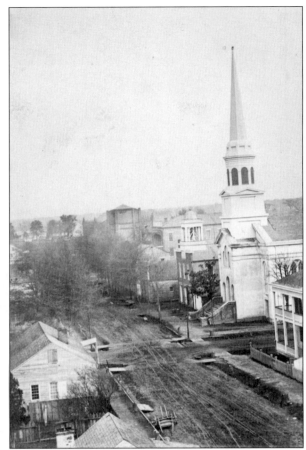

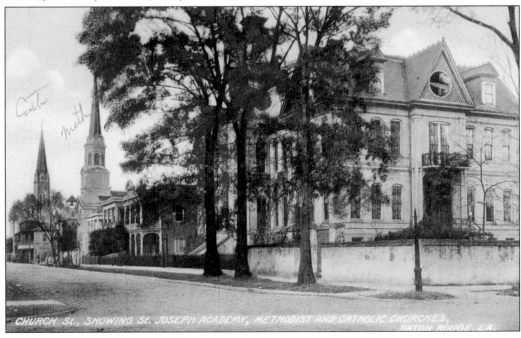

CHURCH St., SHOWING St. JOSEPH ACADEMY, METHODIST AND CATHOLIC CHURCHES, BATON ROUGE, LA.

The Presbyterian congregation traces its founding to the ministry of John Dorrance, who in 1827 began regular services and started a Sunday school in Baton Rouge. The church built this Gothic Revival building, which still houses the congregation, on North Boulevard in 1926. This image was taken within a year after the building was completed. (Courtesy of the *History of the First Presbyterian Church of Baton Rouge, Louisiana*.)

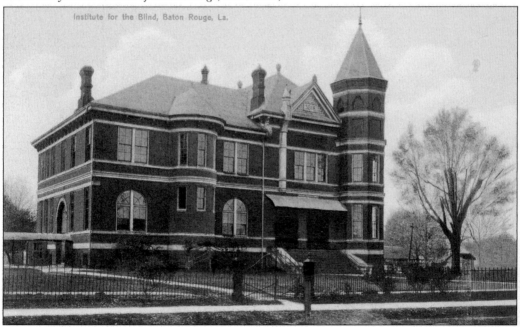

The State School for the Blind, shown here around 1920, split off from the Asylum for the Deaf, Dumb, and Blind in 1890 and has remained in this building at 1120 Government Street ever since. The school is now known as the Louisiana State School for the Visually Impaired. (Courtesy of the Leroy S. Boyd Papers, Postcard Album, LLMVC, LSU Libraries.)

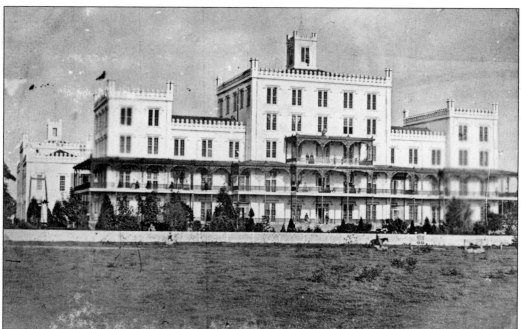

The Louisiana state legislature authorized the founding of the Asylum for the Deaf, Dumb, and Blind in 1852, and the school occupied an old building on South Boulevard until the beautiful Gothic Revival building shown above was completed in 1859. After 10 years, 133 students from Louisiana State University moved in to share the space after a fire destroyed the university's campus in Alexandria. The university moved from here into the Pentagon Barracks in 1887, and in 1890, the State School for the Blind moved into a new location on Government Street. The classic old building was condemned in 1944, and three years later, as shown in the image at right, the last remaining portion was razed. (Above courtesy of the Andrew D. Lytle Collection, LLMVC, LSU Libraries; right courtesy of *The Pelican*, 1947, Louisiana School for the Deaf.)

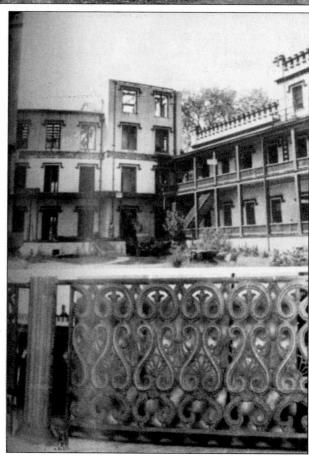

St. Joseph's Academy, a local school for Catholic girls, began as an orphanage and school in 1868. The state legislature chartered the school in 1875. One of the early campuses, shown here, was on the corner of Fourth (then Church) and Florida Streets. In 1941, the school moved to its current location at 3015 Broussard Street. (Courtesy of the Leroy S. Boyd Papers, Postcard Album, LLMVC, LSU Libraries.)

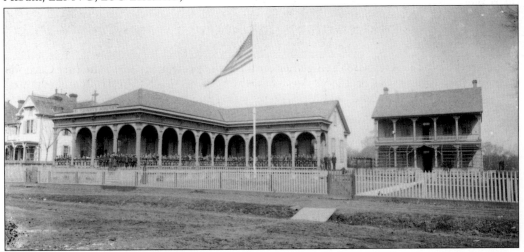

The Brothers of the Sacred Heart began holding temporary classes for boys in 1891 but did not permanently establish St. Vincent's Academy until 1894. The teachers and students shown here pose in their L-shaped building on North Street around 1900. In 1929, a new building replaced this one, and the school became the Catholic High School. Later the school moved to Hearthstone Drive. (Courtesy of the Andrew D. Lytle Collection, LLMVC, LSU Libraries.)

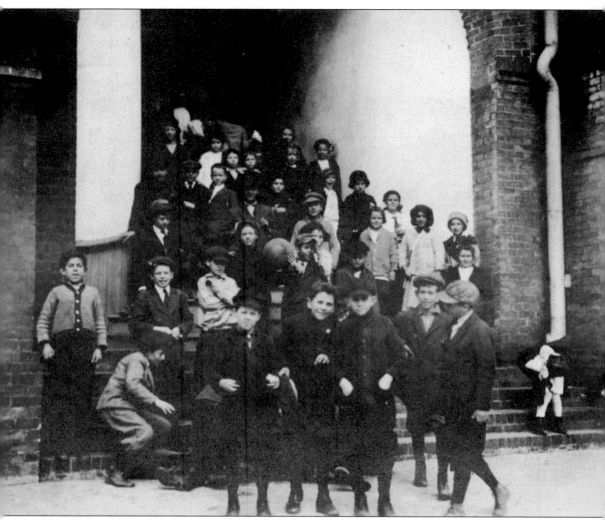

These local Catholic schoolchildren gather on the school's steps in 1924. The first Catholic school in Baton Rouge was St. Mary's Academy, which opened in the late 1840s and admitted only girls. When anti-Catholic sentiment strengthened in that era, the school closed. Yellow fever epidemics doomed St. Peter and Paul's College, which was open from 1850 to 1855, and a second St. Mary's Academy, which was open from 1851 to 1855. The Christian Brothers Institute, operational from 1867 to 1871, was followed by St. Joseph's School for Girls in 1868 and in 1877 by St. Joseph's School for Boys—the immediate predecessor of St. Vincent's. In the early 1900s, St. Joseph's girls' school encompassed both a boarding school and a day school, with classes from kindergarten to high school. St. Vincent's Academy, which served only high school grades, did not allow students to board, though the school made living arrangements for students who lived too far away to travel to the school each day. (Courtesy of the Col. Joseph S. Tate Album, LLMVC, LSU Libraries.)

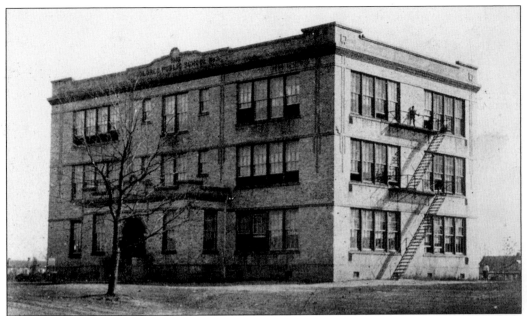

Local African Americans began attending public school in large numbers in the early 20th century. In 1914, the first public brick school building, paid for at state expense, opened in the city. It became known as the Baton Rouge Colored High School. Two years later, four of the school's female students became the first African American public high school graduates in Louisiana. The above building on Reddy Street (now Myrtle Street) and a third school on Scott Street opened soon afterward to serve the expanding elementary grades. By the mid-1920s, the African American high school showed signs of overcrowding. In 1926, therefore, the parish school board erected the McKinley Senior High School. This general science class (bottom) met at McKinley around 1930. (Both courtesy of the State Library of Louisiana.)

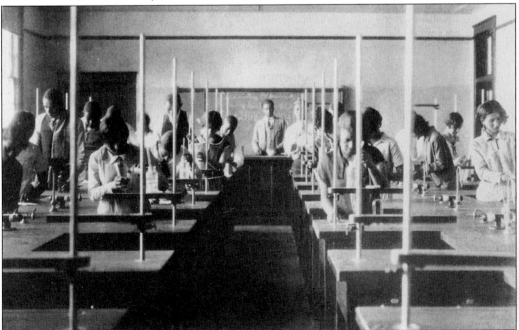

The McKinley school building, shown here in 1990, is located at the corner of Thomas H. Delpit Drive and East McKinley Drive. As the African American segment of Baton Rouge's segregated school system grew, the building for high school students became McKinley Junior High and later McKinley Elementary School. (Courtesy of the State Library of Louisiana.)

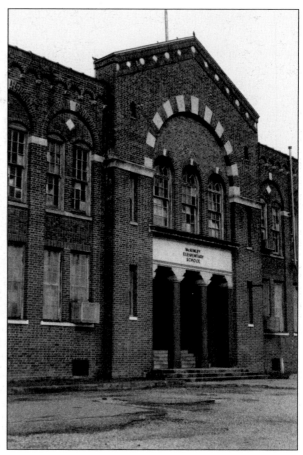

This structure at 700 Perkins Road, shown in the 1930s, replaced the original Baton Rouge Colored High School, which had been damaged by fire in 1928. The city tore it down and built this one, the Perkins Road School. During this era, James Monroe Frazier served as head of the African American portion of the city's school system for 20 years. (Courtesy of the State Library of Louisiana.)

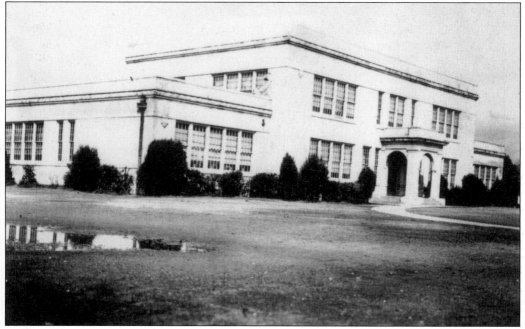

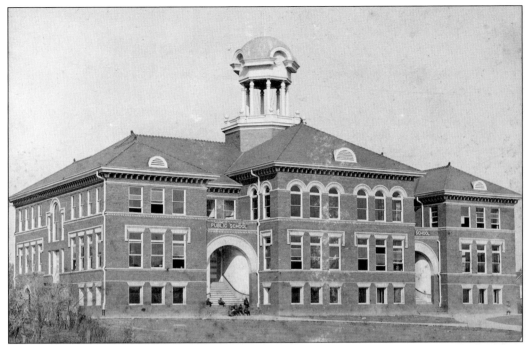

The Baton Rouge Public School, shown around 1902, held classes for all grades in the late 19th and early 20th centuries. Located on a block bordered by North Boulevard and Convention, Ninth, and Tenth Streets, the school was later named the Convention Street School. In order to make way for the new interstate, workers tore down the building in 1957. (Courtesy of the Andrew D. Lytle Collection, LLMVC, LSU Libraries.)

This building served as the home of the Baton Rouge High School at the corner of Florida and Tenth Streets from 1913 until 1926, when the new high school building opened on Government Street. After that point, this structure became the Baton Rouge Junior High School. (Courtesy of the Baton Rouge High School yearbook, *The Fricassee*, 1927.)

Three

1866–1909

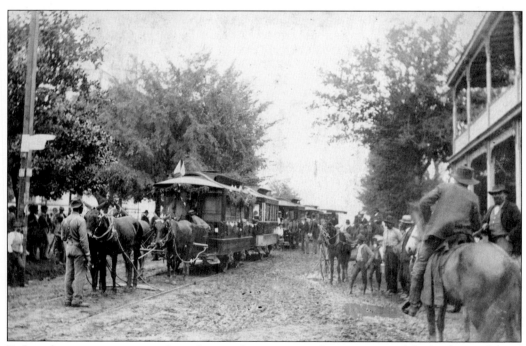

Before the streets were paved, mud was a frequent impediment to travel for both people and wagons. Mule-drawn trolley cars, shown here around 1890, had a somewhat easier time of it. The trolley line ran west on Main Street, south on Lafayette and St. Louis Streets, east on Government Street, and north on Dufrocq (now Sixth) Street back to Main. (Courtesy of the Andrew D. Lytle Collection, LLMVC, LSU Libraries.)

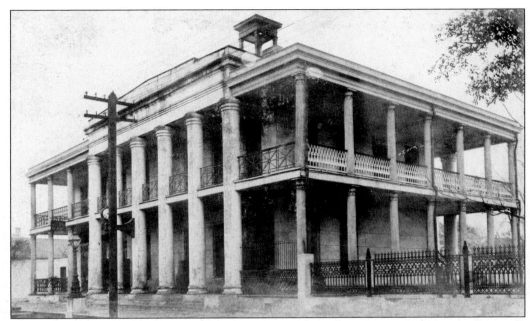

For many years, the town's post office was housed in this building, erected in 1894 at 355 North Boulevard. The U.S. government gave the structure to Baton Rouge in 1932 in exchange for other concessions, and it served as the city hall for 25 years. The City Club, a private organization for men, became the building's owner in the late 1950s. (Courtesy of the Charles East Papers, LLMVC, LSU Libraries.)

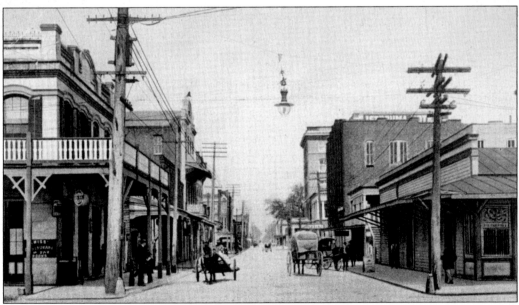

Louisianans first encountered electricity at the 1884 Cotton Centennial Exposition in New Orleans, and six years later, the Baton Rouge Electric Company brought the new invention to the capital city. Electric streetlights illuminated the dirt streets of Baton Rouge soon thereafter. This postcard shows one of the first streetlights on Third Street. (Courtesy of the Leroy S. Boyd Papers, Postcard Album, LLMVC, LSU Libraries.)

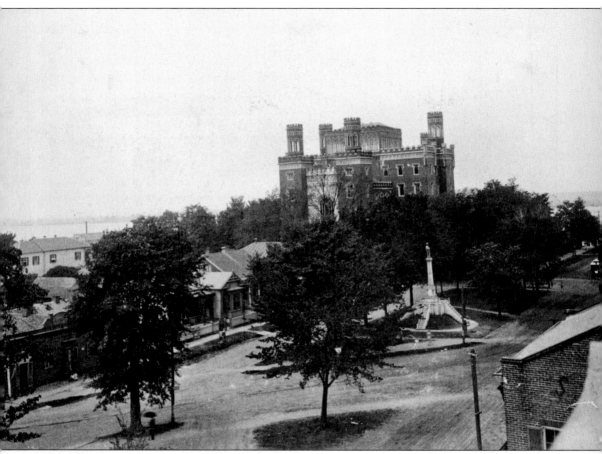

The Old State Capitol, shown here around 1900, sported a coat of red paint—a visual reminder of the town's "Red Stick" origins—and turrets for about 25 years. As the legislature prepared to return from New Orleans to Baton Rouge in the early 1880s, William Freret renovated the building. Some, like Mark Twain, who called it "an architectural falsehood," would have preferred to see it torn down. The state repaired the building after a fire in 1907, removing the iron turrets and changing the color back to white. The foreground of the photograph shows the Confederate monument at the corner of North and Third Streets. Its base was completed in 1886, and the soldier statue was added in 1890. Baton Rouge had the monument renovated and its base simplified just before the 1961–1965 Civil War centennial. This photograph may well have been taken from the roof of the post office building. (Courtesy of the LSU Photograph Collection, RG A5000, University Archives, LSU Libraries.)

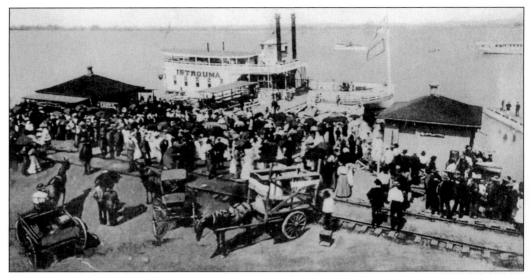

From around 1835 to 1968, ferry boats running from Baton Rouge to Port Allen on the west bank provided reliable transportation to people traveling across the Mississippi River, opening up new avenues of trade for the town in the 19th century. The bustling ferry landing, *c.* 1870, is shown in this postcard. (Courtesy of Greater Baton Rouge Postcards, LLMVC, LSU Libraries.)

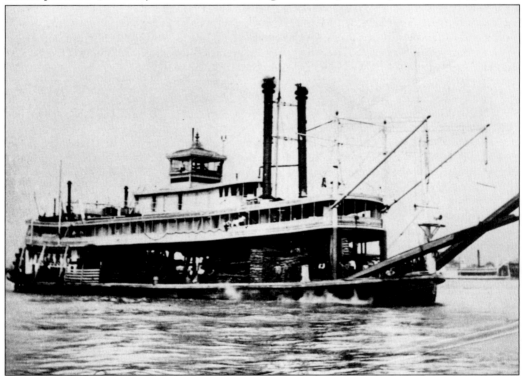

Steamboats, once vital for their ability to transport goods and people quickly and reliably along the Mississippi River, played an important role in the port city of Baton Rouge. This steamboat, the *William Garig*, traveled between New Orleans, Baton Rouge, and Bayou Sara for the Carter Packet Company of New Orleans, which commissioned the ship in 1904. (Courtesy of the State Library of Louisiana.)

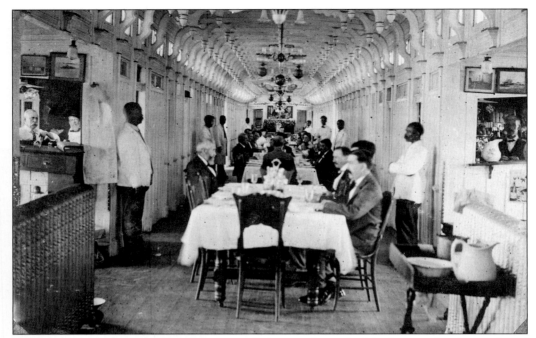

Paying passengers enjoyed pleasant accommodations, as shown in this photograph taken on board the steamship *Star America* around 1900, in which contented travelers ate lunch in the ornate dining hall while their white-jacketed waiters stood at attention behind them. This photograph echoes artist Adrien Persac's 1861 painting of the interior of the *Princess*. (Courtesy of the Sophie Cooley Pearson Papers, LLMVC, LSU Libraries.)

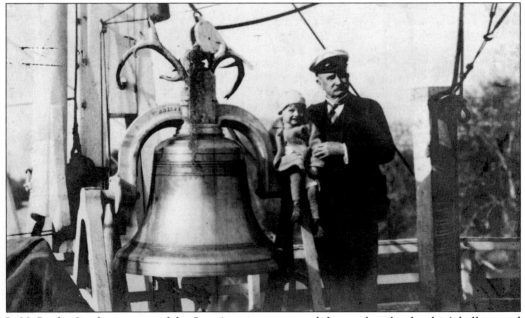

L. V. Cooley Jr., the captain of the *Star America*, poses with his nephew by the ship's bell around 1920. Both Cooley and his father worked as steamboat captains, running their boats on the Mississippi River from 1898 to 1926. Their families lived with them on the riverboats or in ports of call. (Courtesy of the Sophie Cooley Pearson Papers, LLMVC, LSU Libraries.)

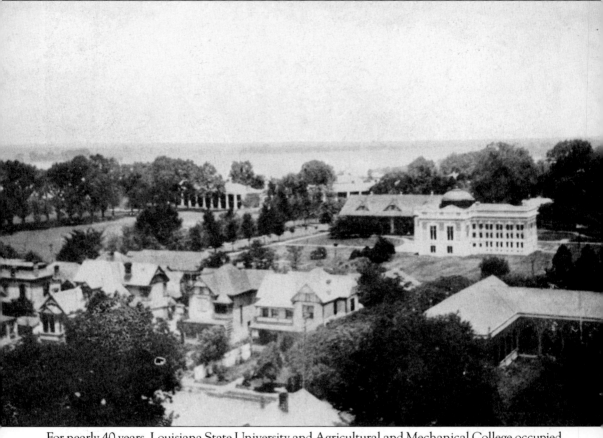

For nearly 40 years, Louisiana State University and Agricultural and Mechanical College occupied about 200 acres of land downtown in the area that is now the state capitol grounds. This pre-1908 photograph shows how different downtown Baton Rouge looked more than a century ago. The domed building on the right side of the image is the original Hill Memorial Library, named after benefactor John Hill. It would be destroyed in 1956 to make way for the new State Library of Louisiana. To its left sat Garig Hall, named after wealthy local businessman William Garig. Across the street, then called University Avenue and now Third Street, at the far left can be seen the columns of the Pentagon Barracks, formerly an army base, and the Mississippi River behind it. The area in the foreground, outside the boundaries of the campus, shows local housing styles from the turn of the 19th century. The only buildings left today are the Pentagon Barracks. (Courtesy of the LSU Photograph Collection RG A5000, University Archives, LSU Libraries.)

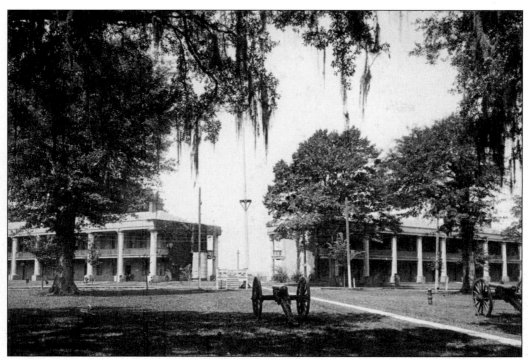

In 1824, the U.S. Army built the Pentagon Barracks at Baton Rouge; in 1887, Louisiana State University and Agricultural and Mechanical College made the barracks its home. This view, taken from the east side in the early 1900s, gives a glimpse of the Mississippi River behind the buildings. (Courtesy of the LSU Photograph Collection RG A5000, University Archives, LSU Libraries.)

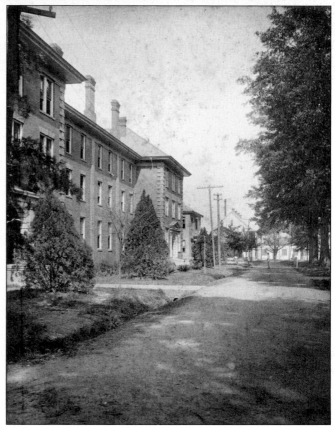

Large trees shaded many of the streets of downtown Baton Rouge at the beginning of the 20th century. At left is LSU's Foster Hall, a cafeteria and dormitory built in 1901 and named for Gov. Murphy J. Foster. Beyond it sat a laboratory, classrooms, and machine shops. (Courtesy of the LSU Photograph Collection RG A5000, University Archives, LSU Libraries.)

Many LSU professors lived in modest, comfortable homes. John F. Welch, an assistant professor of mathematics, owned this house near the school on University Walk. The street ran for two blocks just south of Spanish Town Road. Some of the 19th-century homes still exist. (Courtesy of the William Wallace Garig Family Papers, LLMVC, LSU Libraries.)

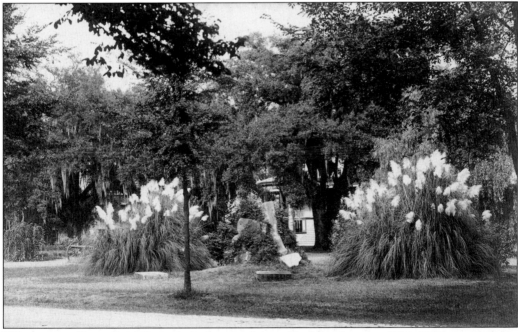

Then as now, Baton Rouge's residential streets boasted lush landscaping. This 1902 picture shows University Walk, which in some spots was so filled with plant life that the homes behind could hardly be seen. The white-tipped mounds are pampas grass, and behind them are live oak trees dripping with Spanish moss. (Courtesy of the University Archives, LLMVC, LSU Libraries.)

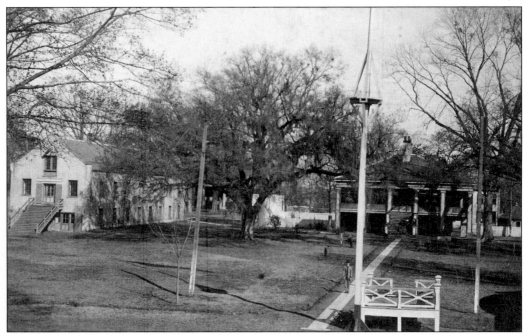

This rare *c.* 1899 photograph shows the LSU chemistry building, at left, and the two-story president's home. James W. Nicholson, a professor of mathematics, and Thomas D. Boyd, a professor, commandant, and administrator (and David French Boyd's brother), served as the university's presidents during the time LSU was housed downtown. (LSU Photograph Collection RG A5000, University Archives, LSU Libraries.)

This beautiful live oak tree near the Pentagon Barracks once shaded the president's home. At bottom right in this *c.* 1902 photograph, LSU president Thomas D. Boyd stands in the tree's shadow. In 1937, the Baton Rouge Garden Club placed a plaque at the live oak's base commemorating its historical significance. (Courtesy of LSU Photograph Collection, University Archives, LLMVC, LSU Libraries.)

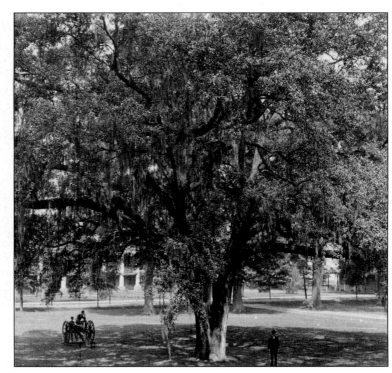

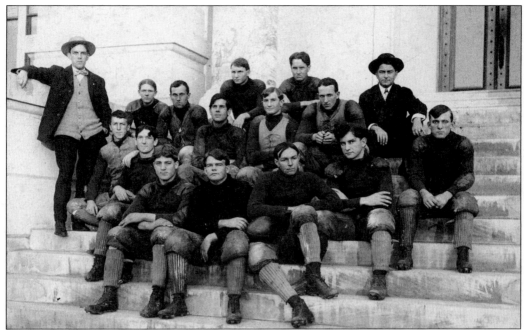

LSU football, popular long before Tiger Stadium existed, started in 1893 when the first team lost the only game of its first season to Tulane. They lost their first home game in 1894 to Ole Miss, but the Fighting Tigers improved quickly. The 1905 team is shown here on the steps of the old Hill Memorial Library. (Courtesy of LSU Photograph Collection RG A5000, University Archives, LSU Libraries.)

From 1870 to 1920, LSU used the old arsenal, once a storage building for gunpowder and ammunition, as a barn and veterinary hospital. Originally built in 1838 as part of the federal military base in the town, the arsenal was turned into a museum in the 1960s. (Courtesy of the LSU Photograph Collection RG A5000, University Archives, LSU Libraries.)

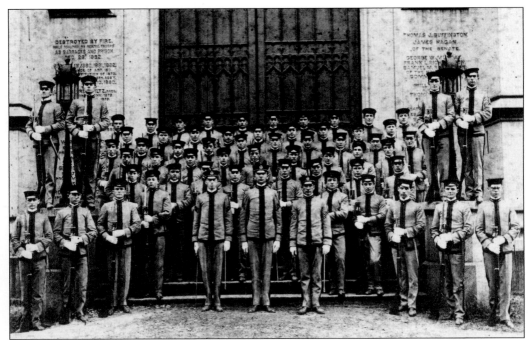

The cadets of Company A, LSU, stand on the steps of the capitol around 1907. From its founding until 1969, when its Reserve Officers' Training Corps program became voluntary, LSU required that its male academic students also take military training as a component of their education. Its military program gave LSU the nickname "Ole War Skule." (Courtesy of the State Library of Louisiana.)

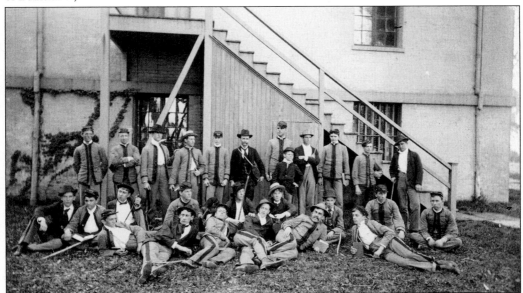

This photograph shows an LSU botany class at leisure in the early 20th century. LSU expanded its academic offerings during this era, establishing the LSU Law School in 1906 and restructuring the programs into three colleges: engineering, arts and sciences, and teachers (later education). By 1907, enrollment had reached a record high of 600 students. (Courtesy of the LSU Photograph Collection RG A5000, University Archives, LSU Libraries.)

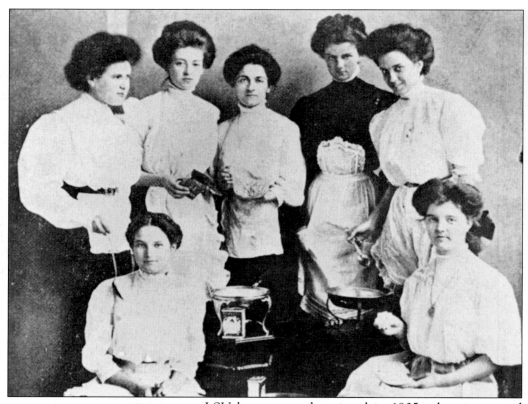

LSU became coeducational in 1905, when it granted a graduate degree to R. Olivia Davis. The first group of undergraduate women consisted of 31 students, including, from left to right (first row) Mary Clark and Ena Paulsen; (second row) Thera Nicholson, Louise Thonssen, Nellie Spyker, Carrie Dougherty, and Gladys Doherty. (*Program Commemorating Fifty Years of Co-education at Louisiana State University, 1906–1956*, courtesy of LLMVC, LSU Libraries.)

Louise and Mercedes, the daughters of prominent Baton Rouge businessman William Garig and his wife, Susan, were among the first class of undergraduate women admitted to LSU in 1906. Both sisters graduated and went on to teach at the university. Shown here is Louise Garig, who spent her career teaching English to LSU students. (*Gumbo* Yearbook, 1906, courtesy of LLMVC, LSU Libraries.)

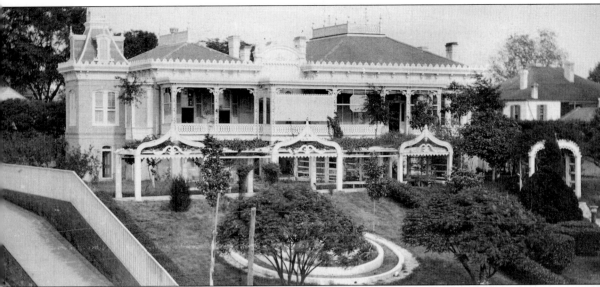

Known for his commercial success, William Garig built this stunning mansion for his family at the corner of Lafayette and Florida Streets, facing the Mississippi River, where the house could easily be seen by travelers. A series of beautiful terraces led from the house down to the river, and the gardens were filled with rare plants. Born in East Baton Rouge Parish in 1839, Garig studied at Centenary College and later worked as a clerk in New Orleans. He enlisted as a Confederate soldier in April 1861 and fought in several campaigns, but he was captured at Port Hudson and held in military prisons until the war's end. Once free, Garig settled in Baton Rouge and embarked on a noteworthy business career, quickly becoming the town's leading wholesale grocer and steamboat agent. He helped found and became president of the First National Bank of Baton Rouge. His other business ventures included hardware, lumber, bricks, the Baton Rouge Waterworks company, and the Capital City Oil Works. Garig died in 1908. (Courtesy of the Andrew D. Lytle Collection, LLMVC, LSU Libraries.)

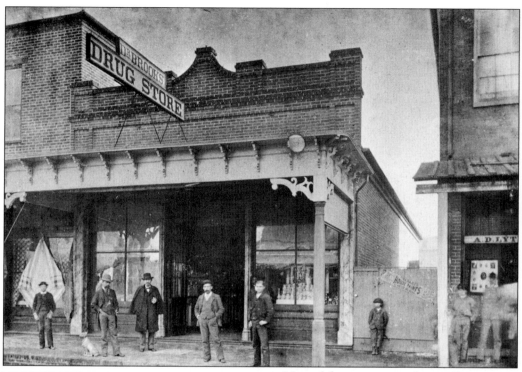

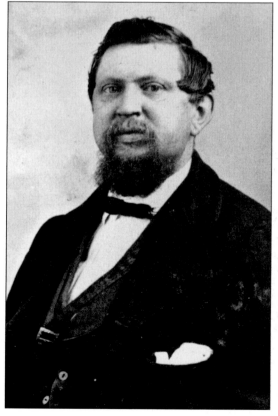

Men of the city pose in front of businesses on the 200 block of Main Street around 1900. To the left is the Dr. F. M. Brooks Drug Store, which opened around 1880. By 1906, Brooks's son, druggist C. M. Brooks, ran the store, which carried medicine, stationery, and dry goods. To the right is Andrew Lytle's photography studio. (Courtesy of the Andrew D. Lytle Collection, LLMVC, LSU Libraries.)

Photographer Andrew D. Lytle (1834–1917) poses for this portrait around 1897. Having moved here from Ohio in 1860, Lytle documented events in Baton Rouge for more than 50 years. He became known nationally in 1911 when many of his Civil War photographs were published in *The Photographic History of the Civil War*. (Courtesy of the Andrew D. Lytle Collection, LLMVC, LSU Libraries.)

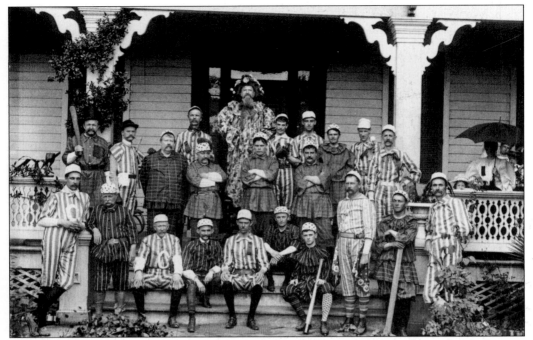

Baton Rouge boasted a group of bravely costumed men who made up a burlesque baseball team. In this 1901 picture, photographer Andrew Lytle stands in the center of the last row on the top step. Wearing their outrageous costumes, the team played baseball games against other local teams and performed at the town Elks Club. (Courtesy of the Andrew D. Lytle Collection, LLMVC, LSU Libraries.)

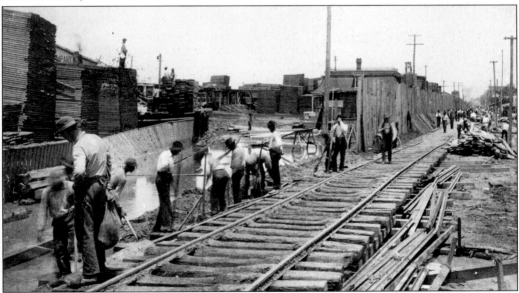

Work progressed along the railroad tracks next to the Burton Lumber Company. By 1901, the lumber company employed some 150 men. The larger of two mills produced 55,000 board feet of lumber per day, and the smaller mill rolled out 40,000 shingles a day. The company supplied a variety of wood products locally, throughout the United States, and to Germany. (Courtesy of the Andrew D. Lytle Collection, LLMVC, LSU Libraries.)

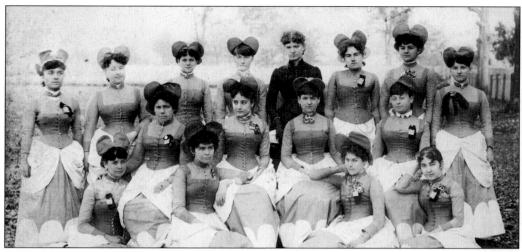

After the Civil War, white residents of cities and towns across the South joined the Confederate Memorial Association. In Baton Rouge, the association's young women members took the name Pansy Circle. Shown here in the 1890s, the group raised support for the Confederate Monument Fund. (Courtesy of the Andrew D. Lytle Collection, LLMVC, LSU Libraries.)

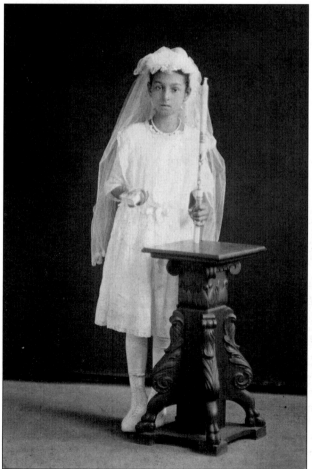

This rare cabinet card photograph shows Dudley Turnbull's daughter, who celebrated her first communion around the turn of the 19th century. She represented an unusual family in Baton Rouge: the Turnbulls had been free people of color before the Civil War. In 1850, free African Americans made up just six percent of the town's population. (Courtesy of the Dudley Turnbull and Family Papers, LLMVC, LSU Libraries.)

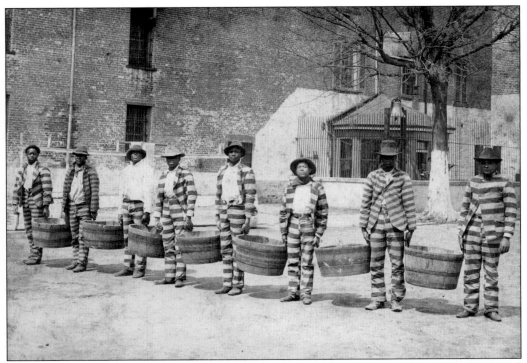

The Louisiana State Penitentiary, built in Baton Rouge in 1935, remained in the city until it moved to Angola Farm, near St. Francisville, in 1917. Although many of the prisoners often performed more dangerous work, such as levee building and repair, as part of a convict-leasing system, the convicts shown here around 1900 worked in the prison's laundry. (Courtesy of the Andrew D. Lytle Collection, LLMVC, LSU Libraries.)

The levees' presence established a certain level of safety for businesses and residents, and maintaining and improving the levees helped attract new commercial ventures. This picture originally appeared in a booster booklet designed to showcase Baton Rouge. Despite this work, in 1912, the river destroyed its levees and flooded Catfish Town, which was south of the downtown area. (*Elks' Souvenir of Baton Rouge, 1901*, courtesy of the LLMVC, LSU Libraries.)

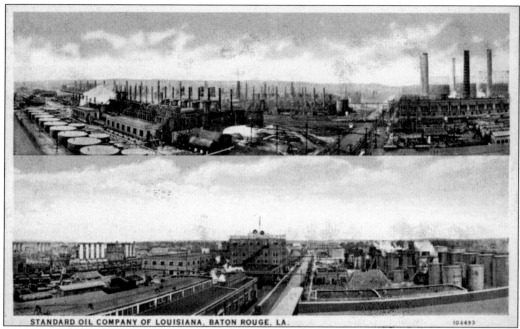

STANDARD OIL COMPANY OF LOUISIANA, BATON ROUGE, LA. 104493

The Standard Oil Company of Louisiana, established in April 1909, fated the future of Baton Rouge to be inextricably tied with the oil industry. Within seven months, a new refinery opened on Choctaw Drive just north of the city. This postcard shows different views of the refinery. (Courtesy of *Pictorial Review of Baton Rouge, Louisiana, 1921*, LLMVC, LSU Libraries.)

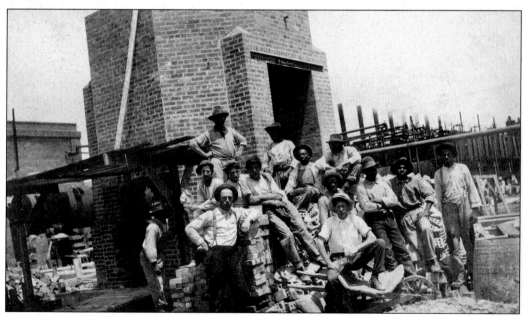

As Standard Oil announced its intentions to build a refinery in Baton Rouge, the town's biggest attraction became its wealth of jobs. Within a decade, nearly 7,000 new residents had moved to Baton Rouge. Construction continued long after the initial refinery opened in 1909. The employees here—a crew of both black and white men—worked together as bricklayers around 1920. (Courtesy of the Charles East Papers, LLMVC, LSU Libraries.)

Four

POLITICIANS

Murphy James Foster, elected governor in 1892 and 1896, went on to serve in the U.S. Senate in 1900. He stood on this platform before Baton Rouge residents during a political campaign. Before the advent of television and other effective ways to reach mass audiences, Baton Rougeans loved the entertaining political rallies that combined lively speeches with free picnics. (Courtesy of Andrew D. Lytle Collection, LLMVC, LSU Libraries.)

Virginia-born James Mason Elam (1796–1865) enjoyed a colorful career as an ensign in the navy, fighting in the War of 1812 and later against the Barbary pirates, before he moved to Baton Rouge in 1820 and became a lawyer. He served as mayor from 1859 to 1860, and his son, James Essex Elam (1829–1873), was elected mayor three times. (Courtesy of the James E. Elam Papers, LLMVC, LSU Libraries.)

In 1888, photographer Andrew Lytle took this portrait of some prominent men and women of Baton Rouge. Standing from left to right are Ernest McMain, Annie Reyaud, former mayor Leon Jastremski, an unidentified woman, and Sidney McMain. Seated from left to right are Nellis McMain, Brunner Burke, and Margaret Chamberlain. Ernest McMain was associated with the Reymond Company. (Courtesy of the Charles East Papers, LLMVC, LSU Libraries.)

Baton Rouge's mayor from 1898 to 1902, Robert A. Hart paid for modernizations to the city's infrastructure by issuing bonds. These bonds financed road improvements and paving, the erection of new schools for both black and white students, and the improvement of sewers and drains. After his term in office, Hart purchased and lived at Magnolia Mound plantation. (Courtesy of the State Library of Louisiana.)

Huey P. Long, a legendary politician, served as governor from 1928 to 1932 and as a U.S. senator from 1932 until his assassination in 1935. Proud to be called "Chief Thief for LSU," Long is shown here in 1934 flanked by two LSU drum majors as he leads the parade before a football game against Ole Miss. (Courtesy of the Russell B. Long Papers, LLMVC, LSU Libraries.)

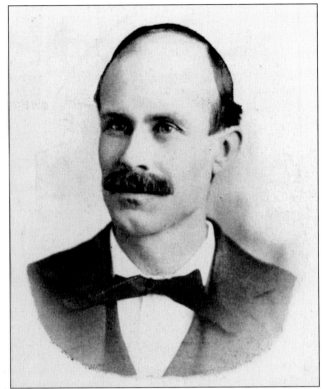

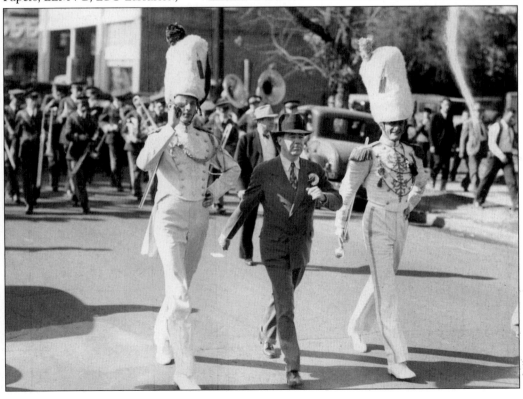

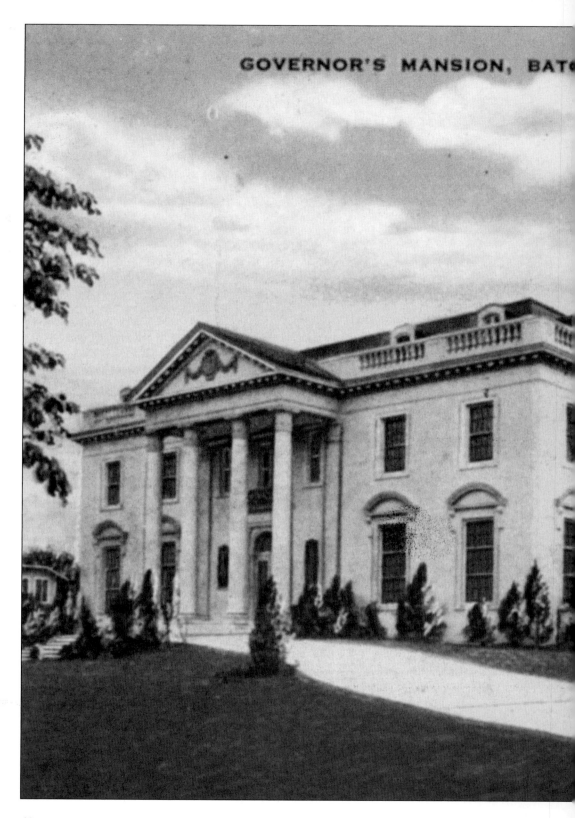

GOVERNOR'S MANSION, BATO

ROUGE, LA.-1

Gov. Huey Long, known as the Kingfish, hated the antebellum-era executive mansion that had housed Louisiana governors on North Boulevard since 1887, so in 1929, he had it torn down overnight. Many of the treasures it held were never recovered. The sudden lack of a gubernatorial home forced the state legislature to finance the building of a modern mansion, erected in 1930. This stunning building served as home for the state's governors and their families until 1963. For a time, it housed the Louisiana Art and Science Museum. Then the building became a historic house museum. In 1998, the Foundation for Historical Louisiana, a preservation organization, moved into the mansion. (Courtesy of Greater Baton Rouge Postcards, LLMVC, LSU Libraries.)

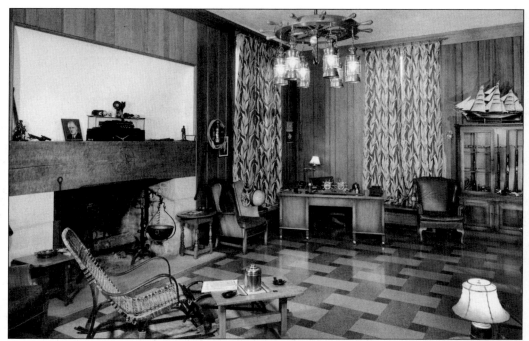

New Orleans architects Weiss, Dreyfous, and Seiferth built the mansion, and because of Long's designs—for the mansion and for his own future—the building looked like the executive mansion in Washington, D.C. It became known as "Louisiana's White House." This spacious yet cozy first-floor room was a library and study. (Courtesy of the State Library of Louisiana.)

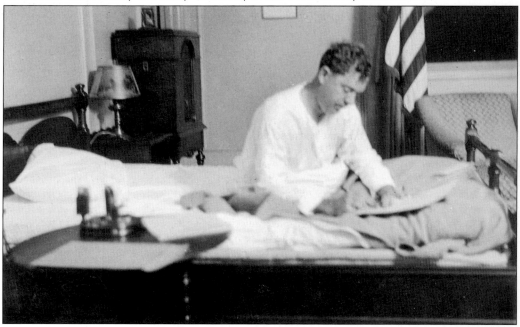

Often, Long preferred to stay in his suite at the Heidelberg Hotel, which had been built in 1927. He became infamous for meeting guests while wearing his pajamas. Shown here in his sleepwear on August 29, 1932, Long worked in bed on the No Crop Bill, which forbade cotton planting in Louisiana for 1933. (Courtesy Huey P. Long Photograph Album, LLMVC, LSU Libraries.)

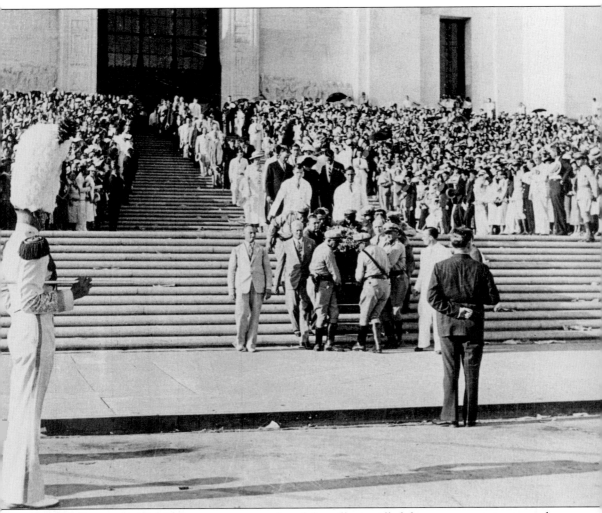

By 1935, the governor had become a senator—though he still controlled the state government—and Long aimed next for the presidency, going so far as to write a book called *My First Days in the White House*. On September 8, 1935, Long was shot in a corridor at the new state capitol. He died two days later at Our Lady of the Lake Hospital. His September 12 funeral drew throngs of people from around the state, some who came to mourn, some simply to witness the event. An LSU drum major in the foreground of this picture harks back to the Kingfish's days leading the university's parades. Rev. Gerald Smith watched as Long's casket was carried down the steps of the capitol. It was buried on the capitol grounds, and in 1938, the state legislature commissioned a memorial statue for the grave site. Erected two years later, the statue faces the statehouse, the site of Long's days of glory and power, as well as the site of his assassination. (Courtesy of the Charles East Papers, LLMVC, LSU Libraries.)

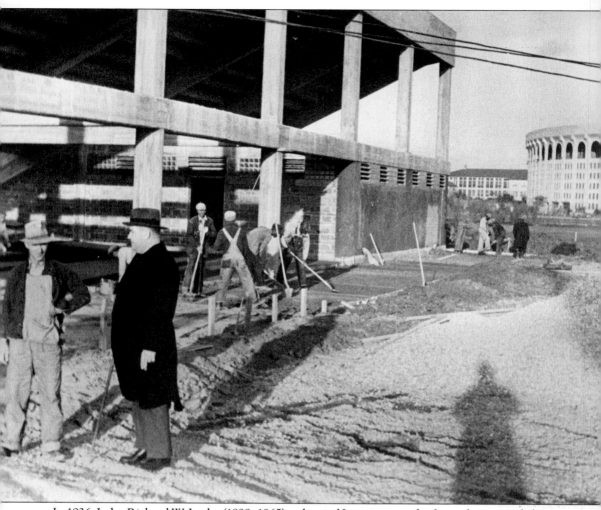

In 1936, Judge Richard W. Leche (1898–1965), a devoted Longite, won the first gubernatorial election after Huey Long's assassination. Through a positive relationship with the federal government, Leche brought a variety of Works Progress Administration (WPA) projects to Louisiana. WPA funds built LSU's Nicholson Hall, the John M. Parker Coliseum, the dormitory addition to Tiger Stadium, and the Alex Box Baseball Stadium, shown here during its construction, as Leche (right) confers with a worker. Nonetheless, Leche used his term as governor to fill his own pockets during a time when political corruption in Louisiana was perhaps at its worst. Leche resigned the governorship in 1939 and quickly became the top miscreant charged in the Scandals of 1939. The following year, Leche was convicted of mail fraud and sentenced to 10 years in prison. After five years, Leche was paroled from the federal penitentiary in Atlanta, and Harry S. Truman pardoned him in 1953. After that, Leche worked again as a lawyer and occasionally as a lobbyist until his death. (Courtesy of the Richard W. Leche Papers, LLMVC, LSU Libraries.)

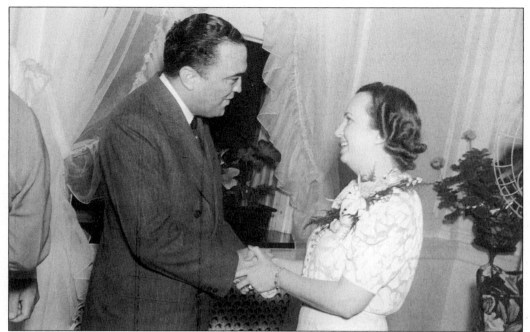

J. Edgar Hoover, head of the Federal Bureau of Investigation, visited Louisiana in May 1939. He attended graduation at LSU and is shown here greeting first lady Elton Reynolds Leche at the governor's mansion. Elton Leche and her husband had two sons, Richard Webster Leche Jr. and Charles Eustace Leche. (Courtesy of the Richard W. Leche Papers, LLMVC, LSU Libraries.)

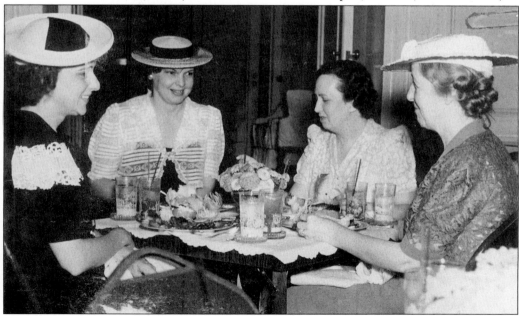

In 1939, the first lady hosted the wives of legislators and government officials at a luncheon at the governor's mansion. Shown from left to right are Dorothy Wimberly, wife of Speaker of the House Lorris M. Wimberly; Blanche Revere Long, wife of Lt. Gov. Earl Kemp Long; Elton Reynolds Leche; and Mary Conway, wife of Secretary of State E. A. Conway. (Courtesy of the Richard Leche Papers, LLMVC, LSU Libraries.)

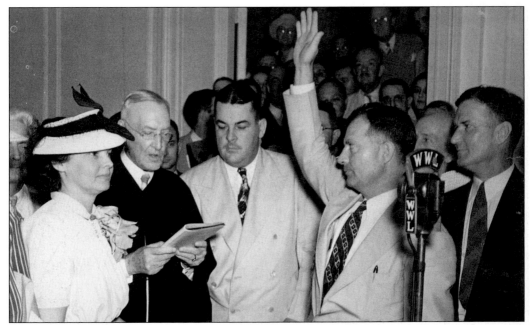

On June 26, 1939, Earl Kemp Long (1895–1960), Huey Long's brother and Leche's lieutenant governor, took the oath of office after Leche's unexpected resignation. Shown from left to right are Blanche Revere Long, an unidentified judge, Richard Leche, Earl Kemp Long, and an unidentified man. Corruption in his organization prevented Long from winning the 1940 gubernatorial election against reformer Sam Jones. (Courtesy of the State Library of Louisiana.)

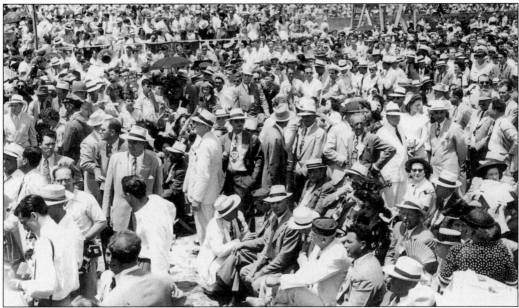

Earl Long defeated Jones in 1948, and the crowds shown here packed LSU's Tiger Stadium to hear his gubernatorial inauguration speech. Elected for governor again in 1956, Long fought the segregationists during his final term in office. Though committed to a mental hospital, he had himself released and ran successfully for congress. Long died before taking office. (Courtesy of the Earl K. Long Papers, LLMVC, LSU Libraries.)

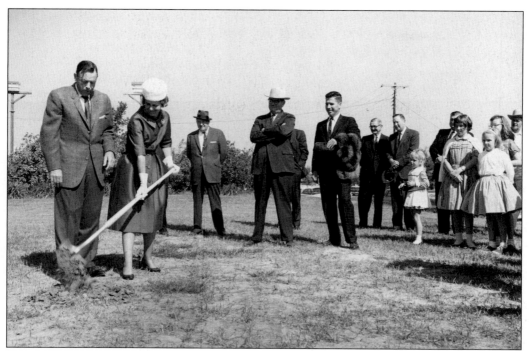

Famous as a singer-songwriter and known for his theme song, "You Are My Sunshine," Gov. Jimmie H. Davis and his wife, Alvern Adams Davis, are shown in 1961 breaking ground for the new million-dollar governor's mansion. Davis, who served as governor in the 1940s and the 1960s, established the Louisiana State Retirement System and built the Sunshine Bridge over the Mississippi River. (Courtesy of the State Library of Louisiana.)

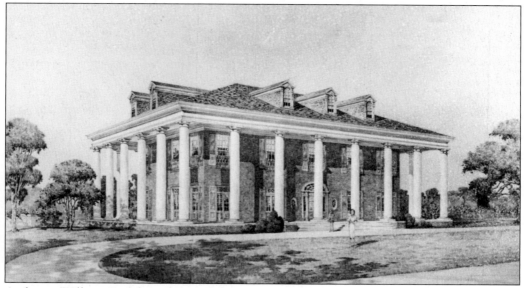

Architect William C. Gilmer designed the new Greek Revival governor's mansion, which sits to the east of the state capitol. It took two years to build. Twenty-one columns adorn the mansion, which was inspired by the Oak Alley plantation house in Vacherie, Louisiana. Later former first lady Alice Foster formed the Louisiana Governor's Mansion Foundation to preserve and operate the building. (Courtesy of the State Library of Louisiana.)

Shown here in 1964, John "Jack" Christian, mayor of Baton Rouge from 1957 to 1964, set up a biracial committee to focus on the issues separating the city's black and white residents and to urge white business owners to hire African Americans. The committee assisted in the desegregation of Baton Rouge's lunch counters in August 1963. (Courtesy of the State Library of Louisiana.)

Opelousas-native Woodrow "Woody" Dumas, shown here at the Capitol House Hotel in 1976, served four consecutive terms from 1965 to 1980 as mayor-president of Baton Rouge. A World War II and Korean War veteran, Dumas played a key role in the building of the downtown Centroplex, now the Baton Rouge River Center. (Courtesy of the State Library of Louisiana.)

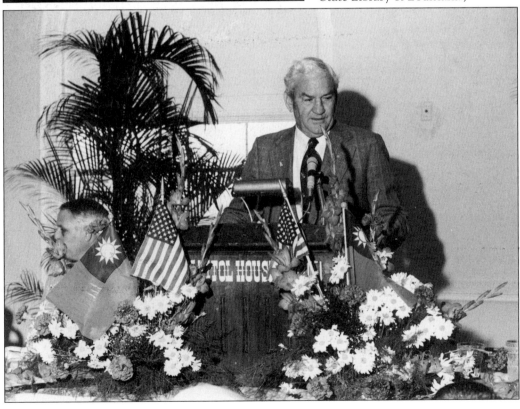

Five

1910–1945

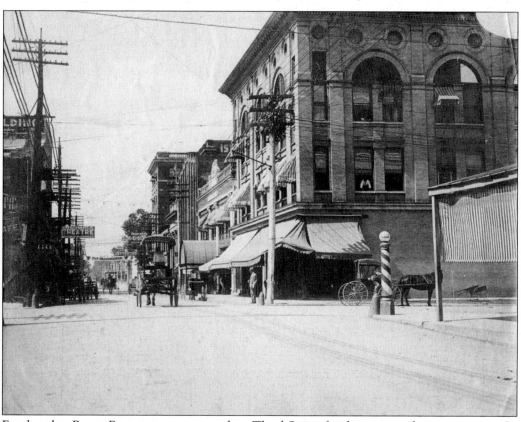

For decades, Baton Rougeans congregated on Third Street for shopping and entertainment. In 1920, the Columbia Theater, on the west side of the street (the left side in this photograph), opened to great approval. It boasted air-conditioning and the first running floor lights in the nation. (Courtesy of the Herbert P. and Marguerite P. Lindee Jr. Memorial Collection, Division of Archives, Louisiana Secretary of State.)

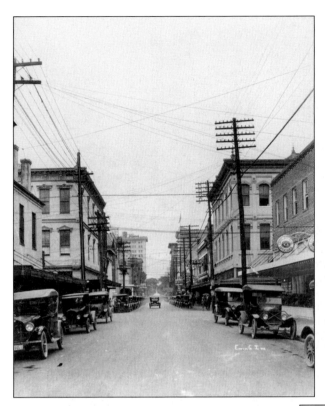

By 1925, as shown in this Jasper Ewing photograph, Third Street looked much more crowded. This view looks southward toward the Confederate Monument at the end of the street. Kress department store—one of the first national chains to open shop in Baton Rouge—can be seen on the right, midway down the street. (Courtesy of the Charles East Papers, LLMVC, LSU Libraries.)

In 1928, a line formed in front of the Columbia Theater, at left. Two years later, it became the Paramount Theater. Izzy's, a popular hangout for LSU students, was next to the movie house. Third Street remained a Baton Rouge shopping standby until the 1950s, when shopping centers grew around the city's core. (Courtesy of the Charles East Papers, LLMVC, LSU Libraries.)

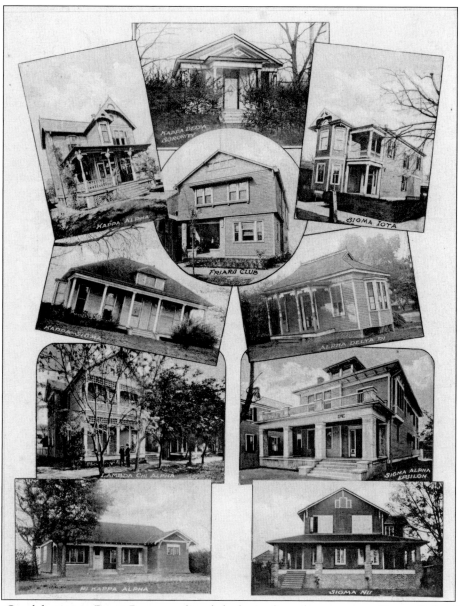

LSU's Greek houses in Baton Rouge are listed clockwise from the top center: Kappa Delta, Sigma Iota, Alpha Delta Pi, Sigma Alpha Epsilon, Sigma Nu, Pi Kappa Alpha, Lambda Chi Alpha, Kappa Sigma, Kappa Alpha, and the Friars Club. Kappa Delta sorority originated in 1897 at the Virginia State Female Normal School. Sigma Iota, the first U.S. Latin American–based fraternity, began at LSU as the "Sociedad Hispano-Americana." Alpha Delta Pi, founded in 1851 at Wesleyan College, is the oldest sorority in the world. Sigma Alpha Epsilon fraternity originated in 1856 at the University of Alabama. The Sigma Nu fraternity began at Virginia Military Institute in 1869. Pi Kappa Alpha began at the University of Virginia in 1868. A younger fraternity, Lambda Chi Alpha, began in Boston in 1909, and the LSU chapter started in 1910. Originally founded in 1400 in Bologna, the U.S. version of Kappa Sigma began in Virginia in 1869. Kappa Alpha dates to 1865. The Friars Club, founded in 1907, built the Deke House in 1910. (Courtesy of the William Wallace Garig Family Papers, LLMVC, LSU Libraries.)

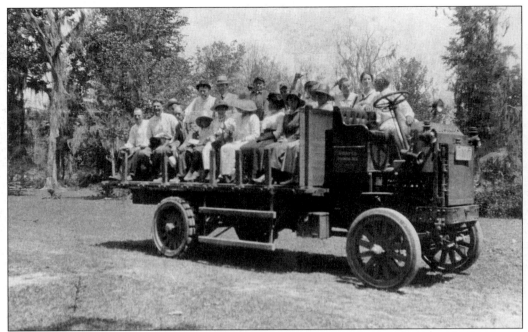

A truckload of LSU faculty and friends sets off on a blackberry-picking expedition on the downtown campus in June 1917. The military truck's grooved rear tires likely provided good traction in muddy terrain. The LSU Agricultural Center relied on trucks like these in its extensive farming operations. (Courtesy of the State Library of Louisiana.)

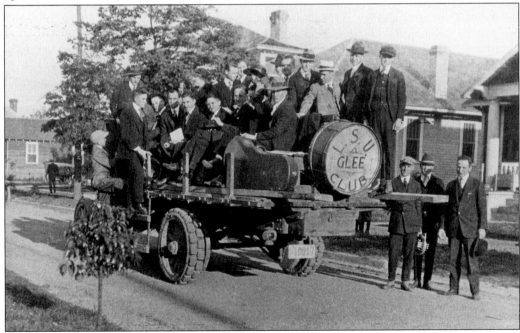

Founded in 1915, the LSU Glee Club—the oldest choir at LSU—is pictured in April 1917 as it prepares to travel to a performance at a venue off-campus. The popular glee club often played at towns outside Baton Rouge. (Courtesy of the LSU Photograph Collection, RG A5000, University Archives, LSU Libraries.)

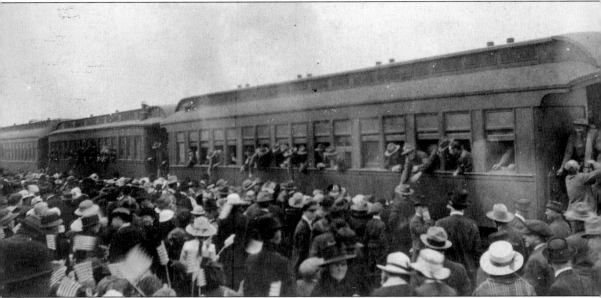

The United States entered World War I in 1917, three years after it had begun, and Louisianans rushed to contribute to the war effort, some doing what they could at home and some serving overseas. Baton Rougean William P. Kidd (1894–1947), who joined the 42nd Division, American Expeditionary Forces, was stationed in Mayschoss, Germany, during the war. In this early 1918 photograph, Kidd and his fellow soldiers lean out the train windows, waving farewell at the station in Baton Rouge, bound for New Orleans and, beyond that, Europe. Kidd participated in at least two battles on the Western Front, at St. Mihiel and Argonne Forest. The end of the war came on Armistice Day, November 11, 1918, and Baton Rouge threw an all-night party to celebrate. Kidd returned home proudly bearing a copy of Gen. John J. Pershing's General Orders No. 38-A, thanking the soldiers for their "splendid service to the army and to the nation." (Courtesy of the William P. Kidd Papers, LLMVC, LSU Libraries.)

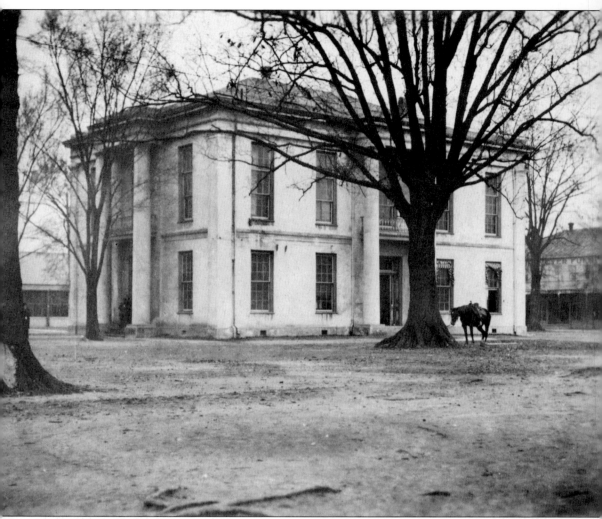

Baton Rouge's old courthouse, built on St. Louis Street in 1857, served the town for many years until it was torn down in 1922, soon after this photograph was taken. The East Baton Rouge Parish government quickly replaced this structure with a new courthouse that opened in 1923. During the Civil War, Union soldiers used the old courthouse as a hospital and camp. On election day in November 1870, after the polls closed and the Republicans won every race, a bloody riot erupted at this courthouse and the Baton Rouge Market, which sat next door. Men fought in the streets, killing four African Americans and injuring 20 white and black people. Federal army troops, called in from their base at the Pentagon Barracks, quelled the fighting. Despite 60 arrests, no one was held liable for the unrest and the murders. All those detained were released. (Courtesy of the Col. Joseph S. Tate Album, LLMVC, LSU Libraries.)

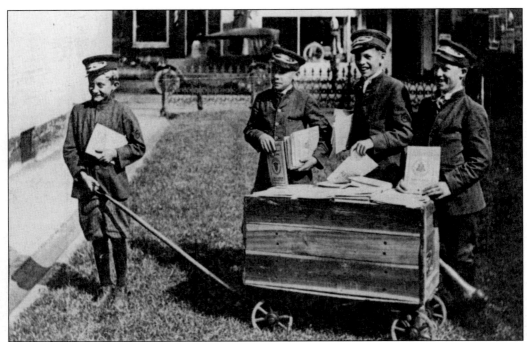

In 1919, Western Union messenger boys delivered new telephone books by pulling wooden wagons. Telephone service arrived in Baton Rouge in the 1890s; within that decade, both the Cumberland Telephone and Telegraph Company and the Merchants and Planters Telephone Company opened locally. By that time, more than 3,000 people worked at Standard Oil and could afford the luxury of home telephones. (Courtesy of the State Library of Louisiana.)

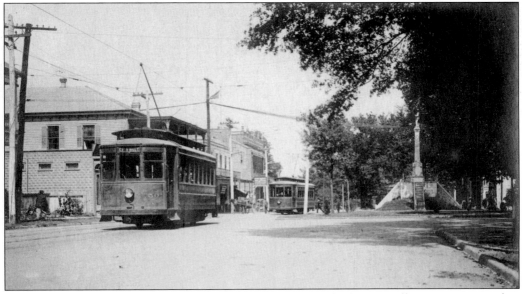

Public transportation in the 1920s had improved from mule-drawn trolleys to a system that consisted of electric trolley lines like this one on North Street. The rails ran along Main, Lafayette, Government, and North Nineteenth Streets, with spurs on North Street and South Boulevard, until 1936. (Courtesy of the Herbert P. and Marguerite P. Lindee Jr. Memorial Collection, Division of Archives, Louisiana Secretary of State.)

A joint effort of various women's organizations in Baton Rouge resulted in the purchase of the Christian Church building on the corner of North and East Boulevards in 1921. The building reopened as the Women's Club in 1922. (Courtesy of the Women's Club, Inc., Records, LLMVC, LSU Libraries.)

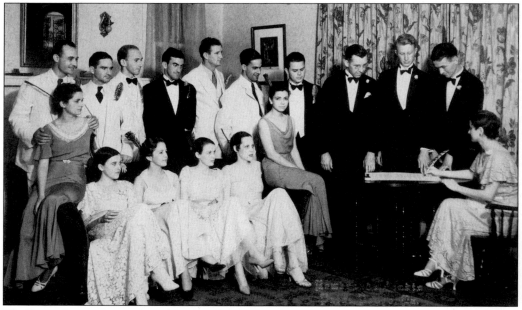

The Baton Rouge Four in Hand Bridge Club hosted this celebration for debutantes at the Women's Club in 1932. Future assistant dean of women at LSU (from 1933 to 1941) Helen Wilkerson is pictured at right, sitting at the table and writing with a feather pen. (Courtesy of the Helen C. Wilkerson Papers, LLMVC, LSU Libraries.)

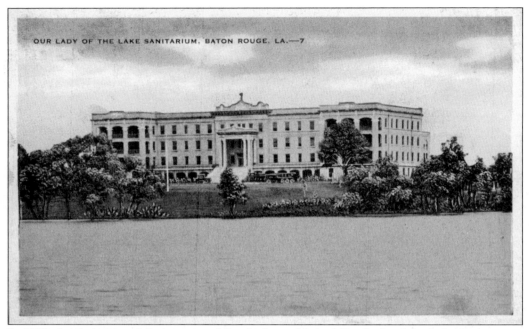

In 1923, the Franciscan Missionaries of Our Lady established Our Lady of the Lake Sanitarium, shown in this postcard soon after its opening. Starting with a modest 100 beds at its downtown location on Capitol Lake, the hospital outgrew its location and, in 1978, moved to its current location on Essen Lane, reopening with 460 beds. (Courtesy of Greater Baton Rouge Postcards, LLMVC, LSU Libraries.)

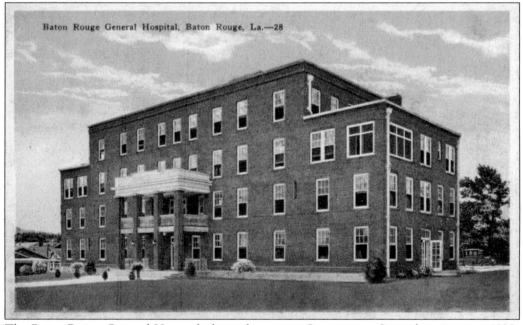

The Baton Rouge General Hospital, shown here at its Government Street location in a 1920s postcard, is now the Baton Rouge General Medical Center. It traces its founding to 1900 when Dr. Thomas Puller Singletary kept two train-wreck victims in one location to make his treatment of them easier. (Courtesy of Greater Baton Rouge Postcards, LLMVC, LSU Libraries.)

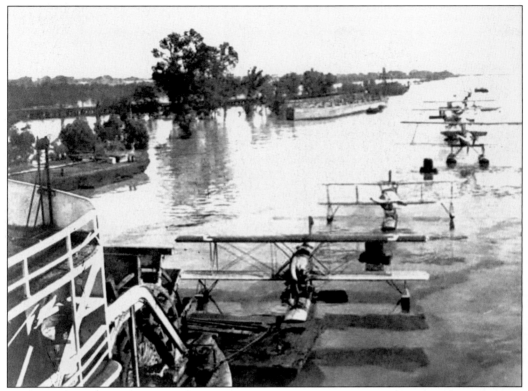

Standard Oil kept a fleet of amphibious planes to reach remote oil wells and exploration sites. The company deployed these aircraft for emergency rescue work after the great 1927 Mississippi River flood, which affected states from Illinois to Louisiana and flooded one-third of the Pelican State. (Courtesy of the Center for Louisiana Studies.)

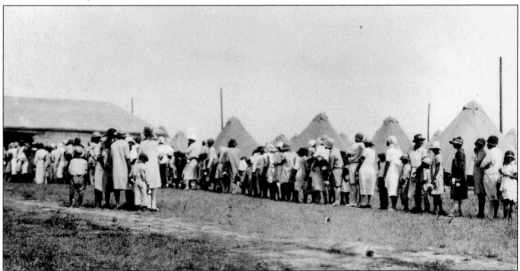

The great flood forced some 700,000 people from their homes. The river broke through levees in more than 100 places and, at its worst, covered an 80-mile-wide swath of land in the country's midsection. Baton Rouge was spared the worst of the disaster, and the capital city became a temporary refuge for evacuees. (Courtesy of the State Library of Louisiana.)

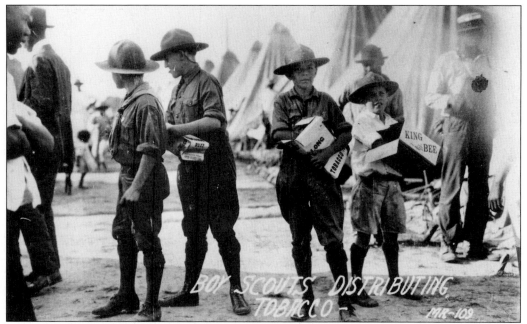

Almost everyone, including local children, pitched in as best they could to help those who had been evacuated. The Baton Rouge Boy Scouts, shown here, doled out tobacco in the tent city that sprang up, providing some little comfort to those who had lost their homes. One of the local tent cities remained in place for five months. (Courtesy of the State Library of Louisiana.)

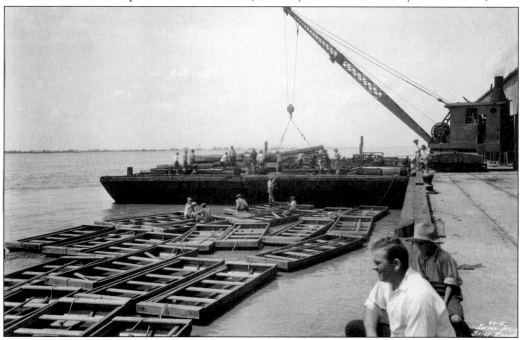

Baton Rouge workers, shown here loading johnboats at the municipal docks, helped aid in flood relief. They shipped supplies upriver as far as Memphis and downriver to New Orleans. The Red Cross, headed at that time by future president Herbert Hoover, oversaw much of the clean up. (Courtesy of the Mississippi River Flood of 1927 Album, LLMVC, LSU Libraries.)

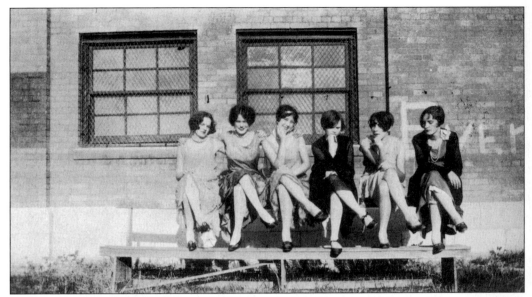

Margaret Dixon, who would become the first female city editor at the *Morning Advocate*, is shown here with her friends from Rosenfield's Department Store. Pictured from left to right are Rubye Lane, Virginia Whitmire, Ciel Riveau, Vidah Pollet, Dolly Roe, and Margaret Dixon. (Courtesy of the Margaret Dixon Papers, LLMVC, LSU Libraries.)

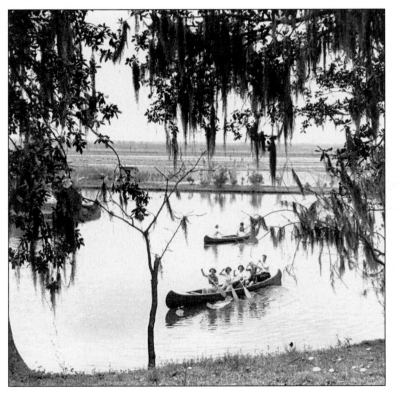

City Park Lake, built in the 1920s, provided new local recreational opportunities, as the canoers in this photograph show. Although the lake is not deep enough for swimming, it provides a good spot to fish and serves as a habitat for many types of birds. The city constructed its companion, University Lake, from a swamp in 1934. (Courtesy of the State Library of Louisiana.)

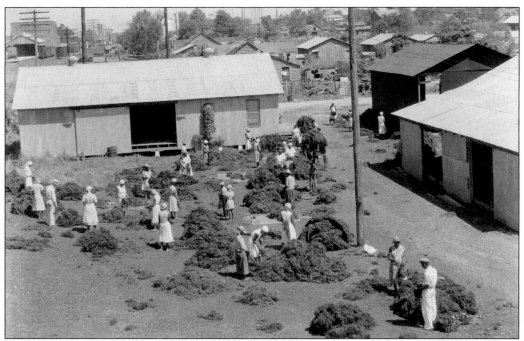

The cleaning and marketing of Spanish moss, a plant that can often be found on live oak trees, provided unique industrial opportunities for Louisianans. The moss was cleaned in a moss gin, dried, and used as insulation and in mattresses. In the late 1930s, Jasper Ewing took this photograph of employees at Sidney B. Webb's moss factory near the railroad. (Courtesy of the Jasper Ewing Photograph Collection, LLMVC, LSU Libraries.)

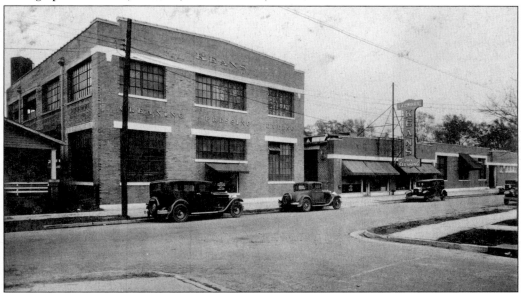

In 1900, the Kean family started Southern Steam Laundry on Government Street. Within six years, they moved to Third Street and renamed their company Kean Brothers. After a 1924 fire destroyed their building, they moved into this brick structure at the corner of Dufrocq (now North Nineteenth) and Convention Streets. The company, shown here in 1932, is now Kean's the Cleaner. (Courtesy of Greater Baton Rouge Photographs, LLMVC, LSU Libraries.)

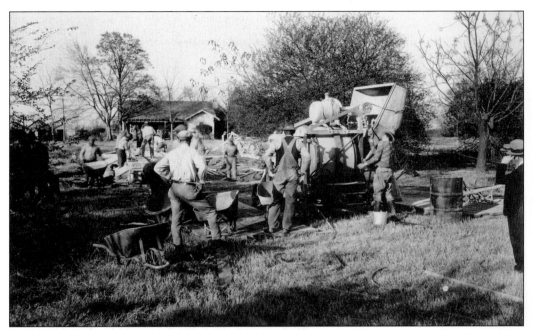

Gov. Huey P. Long insisted on building a new capitol, the tallest in the nation. These workmen, shown with a cement mixer in 1930, poured the first batch of concrete for the site of the new 34-story statehouse. Architects Weiss, Dreyfous, and Seiferth designed the building, and the George A. Fuller Company worked as the contractor. (Courtesy of the State Library of Louisiana.)

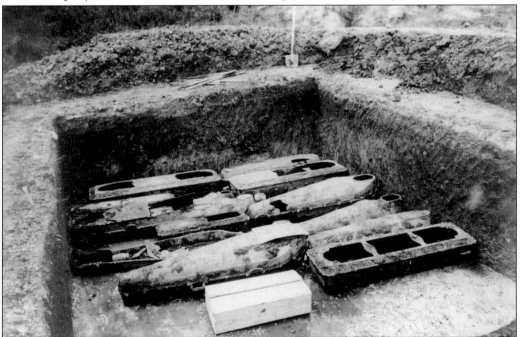

Since the new capitol would be built on the former military base, the same site LSU had occupied before it moved to the old Gartness plantation, workers had to demolish any remaining buildings and clear a large plot of land. In 1931, they found these caskets in a cemetery at the old army post and moved them to a collective burial pit. (Courtesy of the State Library of Louisiana.)

Long built the 450-foot-tall art deco building, clad in limestone from Alabama, in just 14 months at a cost of $5 million. The capitol's construction provided much-needed jobs during the Depression. This picture shows the tower in 1931 as work progressed. (Courtesy of the State Library of Louisiana.)

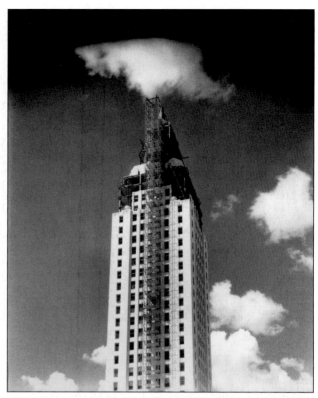

Baton Rouge photographer Fonville Winans, known for taking pictures out of a small airplane as he flew solo, took this picture of ice floating in the Mississippi River—one of his most famous photographs—during the harsh winter of 1940. That same year, rare snow blanketed the city. (Courtesy of the Fonville Winans Collection, LLMVC, LSU Libraries.)

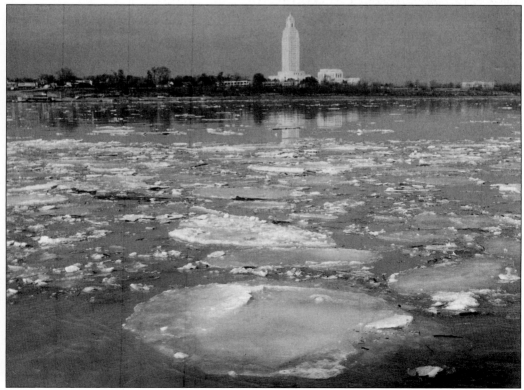

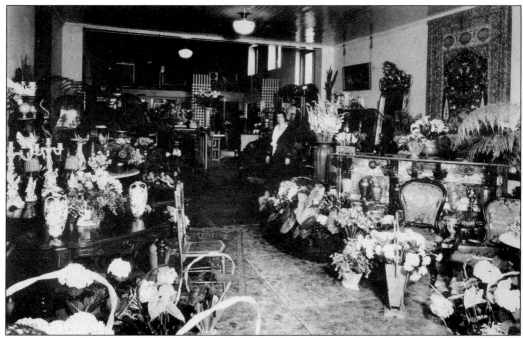

MacDowell and Rena Anderson opened Anderson's Floral Gardens around 1924 at 351 Main Street. They changed its name to Anderson's Florist and Tea Room, and the shop thrived, as shown in this 1930s photograph. An advertisement for the tearoom invited local ladies to shop and relax. (Courtesy of the Greater Baton Rouge Photographs, LLMVC, LSU Libraries.)

Originally a beauty shop, the Cooper and Bramer Health Facility opened around 1922 in the Reymond building on Main Street and expanded its services over the years. By the 1930s, as shown, the spa advertised itself as a "Beauty Specialist and Turkish Baths." (Courtesy of the Greater Baton Rouge Photographs, LLMVC, LSU Libraries.)

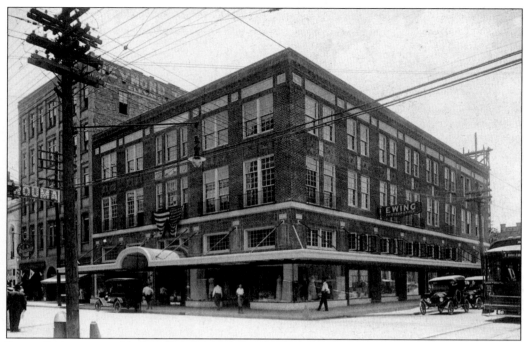

Jasper Ewing, a notable local photographer of the era, took this picture of his studio in the Mayfield Hotel building on Third Street. Ewing captured the community on film from the early 1920s through 1950, working for the Louisiana Highway Commission in the 1920s and 1930s. He is best known for his images of the 1927 Mississippi River flood. (Courtesy of the Jasper Ewing Collection, LLMVC, LSU Libraries.)

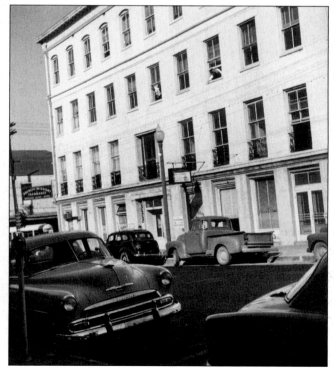

An enterprising businessman built the Harney House Hotel at the corner of Main and Lafayette Streets in the 1840s to provide lodging for state legislators. In 1862, Union gunfire hit the hotel, and later in the 19th century, it burned down. A new hotel on the same site, the Hotel Grouchy (pronounced grew-SHAY), was renamed the Louisian and is shown here in 1950. (Courtesy of the *Register* Records, LLMVC, LSU Libraries.)

In 1938, Fonville Winans took this classic photograph in Port Allen on the west side of the Mississippi River, across from Baton Rouge. The new state capitol is across the river, in the middle of the picture, obscured by smoke, and the old state capitol is visible to its right. Although the Highway 190 bridge would open for automobile and railroad traffic north of the city in 1940, the ferry crossing at Third Street remained active for another 28 years, until the new Mississippi River Bridge, the Interstate 10 bridge, was completed. (Courtesy of the Fonville Winans Collection, LLMVC, LSU Libraries.)

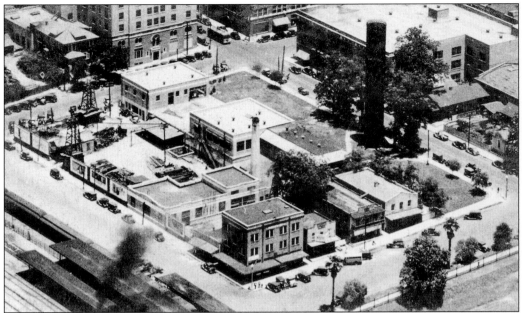

Baton Rouge Water Works, shown here in 1932, stood between River Road and Second Street. The 100-foot-tall standpipe, a water tower made of riveted wrought iron plates, has been painted white and remains in the same spot by the Mississippi River. The new Shaw Center for the Arts now sits to its east. (Courtesy of the Greater Baton Rouge Photographs, LLMVC, LSU Libraries.)

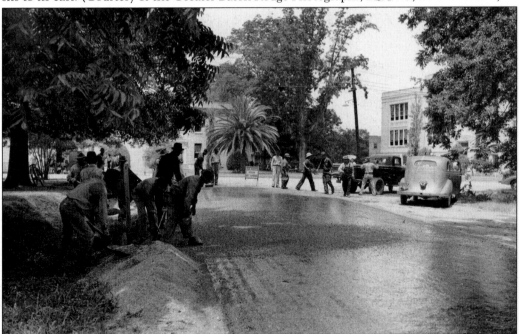

Southern University, a New Orleans institution founded in 1879, moved to Scotlandville in north Baton Rouge and reopened on March 9, 1914. This 1930s photograph shows the paving of one of the university's roads. With limited funding, Southern grew slowly. It has become the largest historically black university system in the United States. (Courtesy of the State Library of Louisiana.)

Shown here under construction in the 1930s, Parker Hall at Southern University was named for Gov. John M. Parker, a progressive who served one term in the statehouse from 1920 to 1924 and died in 1939, around the time Parker Hall opened. At its 1981 renovation, the building was renamed Mayberry Hall after Emma Nesbit Mayberry, Southern's first director of home economics. (Courtesy of the State Library of Louisiana.)

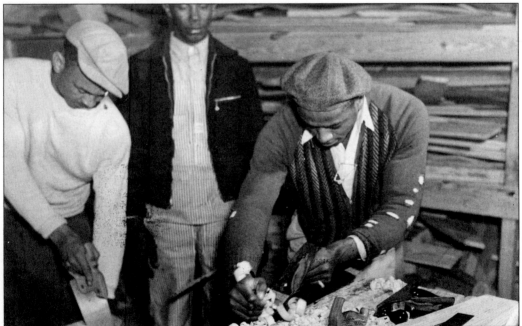

In the 1930s, the WPA held training classes and provided jobs for people suffering from the economic hardships of the Great Depression. Though some of the jobs may have appeared trivial, they successfully taught useful work skills. The Baton Rouge men shown here learned woodcarving in adult education classes near Southern University. (Courtesy of the State Library of Louisiana.)

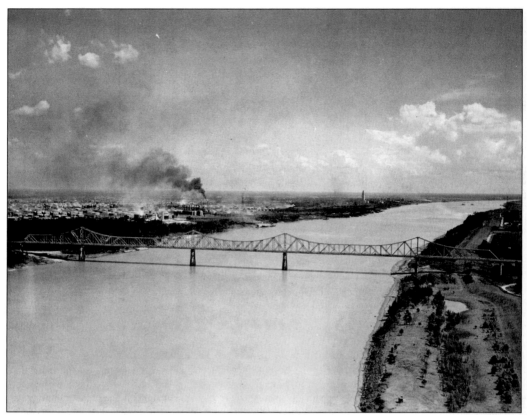

The first bridge to cross the Mississippi River in Baton Rouge, the Highway 190 bridge was designed to carry both trains and automobiles. It opened with great fanfare in August 1940. Both the LSU marching band and the Standard Oil "Stanocola" band performed for the crowds. (Courtesy of the Richard W. Leche Papers, LLMVC, LSU Libraries.)

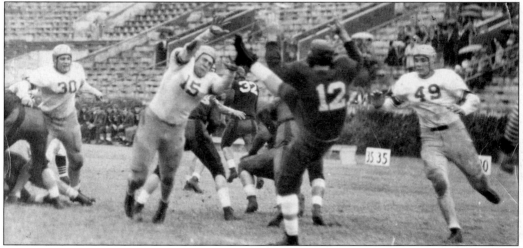

Football has long been a Baton Rouge tradition. At a 1941 freshman game, LSU beat its rival, Tulane University, 21-2. Shown here are LSU players No. 30, guard Oliver B. Frazier; No. 15, tackle Hubert Shutz; and No. 49, end Ruby Harmon. The Tulane players are unidentified. (Courtesy of the State Library of Louisiana.)

Just before the United States entered World War II, the WPA began to clear land and build roads north of Baton Rouge, as shown in this image, in preparation for the building of Harding Field. Soon the military assumed the job and its responsibility, and quickly erected an airport and fighter base. (Courtesy of the State Library of Louisiana.)

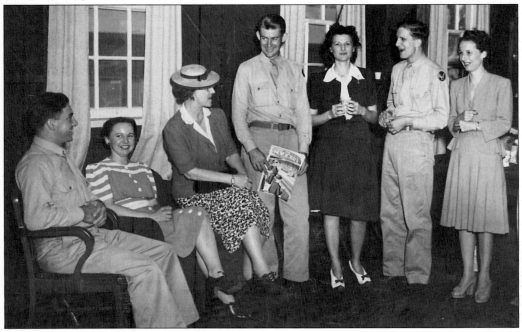

The new Harding Field fighter base trained both men and women to fly planes during World War II. In this photograph, U.S. Army Air Corps men visit with civilian women at the base's library. In 1948, after its military use was over, the airport at Harding Field became the Baton Rouge Metropolitan Airport. (Courtesy of the State Library of Louisiana.)

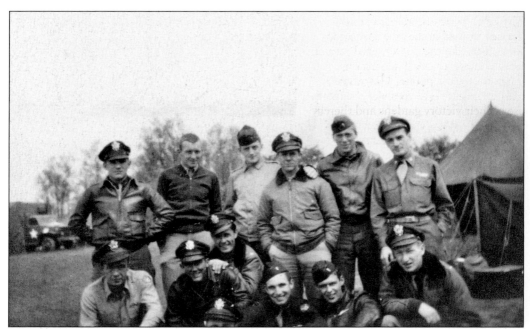

Warren Russell Lobdell, a Baton Rouge native, entered LSU in 1940 and, in 1942, joined the U.S. Army Air Force. As part of his extensive training to be a fighter pilot, he studied at Harding Field, as pictured here in July 1943 (first row, second from left). He died in June 1944 when his Thunderbolt fighter was shot down over northern France. (Courtesy of Warren Russell Lobdell Papers, LLMVC, LSU Libraries.)

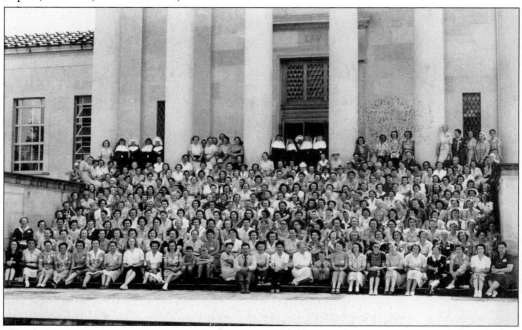

World War II brought a strong military presence to the city, and as in other war efforts, everyone pitched in as best they could. As one example, LSU held a two-day national defense training school for women in August 1942. Jasper Ewing took this photograph of the attendees posed on the steps of the law school. (Courtesy of the State Library of Louisiana.)

The LSU Agricultural Extension
Service trained home demonstration
specialists, like the unidentified women
pictured here, to develop canning
programs for the public. They showed
the community how to make the most
use of their victory gardens and thereby
assist in the war effort. (Courtesy
of the State Library of Louisiana.)

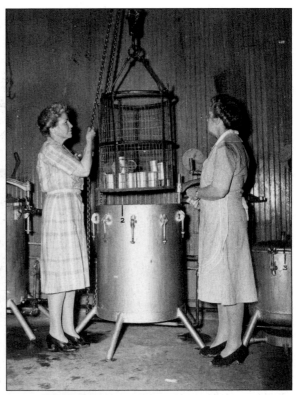

In 1932, Thomas J. Costas started the
first Piccadilly Cafeteria in the Mayer
building at 204 Third Street. He sold
the restaurant to T. H. Hamilton in
1944. During the week, businessmen
and politicians met over breakfast, and
on the weekends, couples would dine
at Piccadilly before going to a movie.
After Sunday services, churchgoers
lined the sidewalk, waiting to eat
lunch. (Courtesy of Piccadilly.)

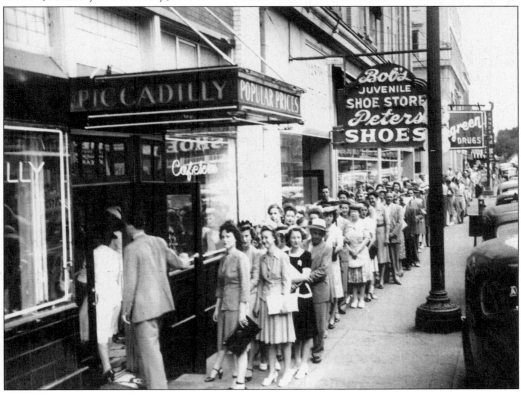

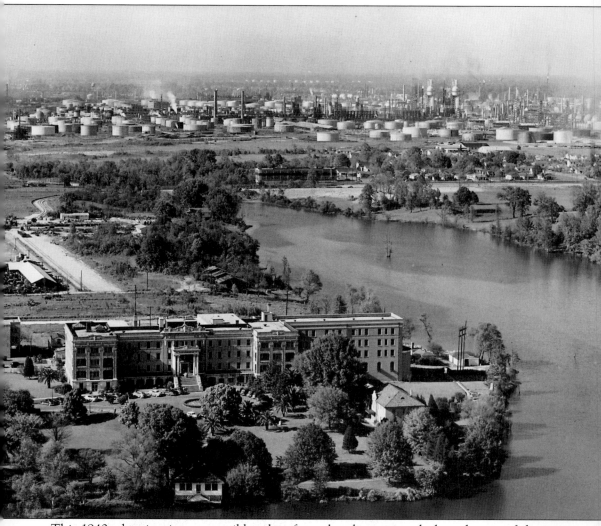

This 1940s sky-view image, possibly taken from the observation deck at the top of the new capitol, shows the original Our Lady of the Lake hospital in the left foreground next to the Capitol Lake and the refineries of Baton Rouge to the north. World War II brought a boom in industry to the city, as existing plants expanded and new ones, such as the Aluminum Company of America, opened. By the end of 1942, the Standard Oil refinery manufactured 76 percent of the aviation fuel produced in the United States, and its chemical products division made much-needed synthetic rubber. Women and African Americans took advantage of great opportunities to prove themselves in new jobs in the military and in the civilian workforce. The city became a boomtown: its population increased from 44,000 in 1940 to 110,000 in 1945, and it was poised for more growth. (Courtesy of the State Library of Louisiana.)

Six

ARTS AND CULTURE

Although he never earned a formal degree in landscape architecture, Steele Burden (1900–1995) designed and planted City Park in the 1920s and went on to serve as the LSU landscaper from 1932 to 1970. He was also instrumental in the landscape design of Shadows on the Teche plantation in New Iberia and Edward McIlhenny's Avery Island. Burden fought in both world wars. (Courtesy of Gerard Ruth.)

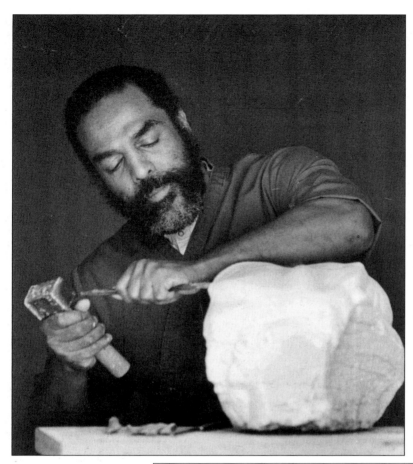

Internationally recognized artist Frank Hayden taught drawing, sculpture, and art appreciation at Southern University from 1961 until his death in 1988. He is best known in Baton Rouge for his sculptures, which can be seen at Louisiana State University and Southern University and downtown at Galvez and Riverfront Plazas. (*Advocate* photograph by Stephan Savoia, courtesy of Capital City Press, the *Advocate*.)

This image shows one of Frank Hayden's sculptures, a 17-foot-high bronze statue of Oliver Pollock installed in 1979 at Galvez Plaza, located by the Baton Rouge River Center (formerly called the Centroplex). Born in Ireland, Pollock (1737–1823) established himself as a businessman in New Orleans and helped to finance the Revolutionary War effort. (Courtesy of the Louisiana Department of Culture, Recreation, and Tourism.)

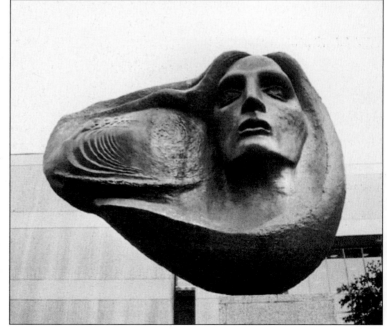

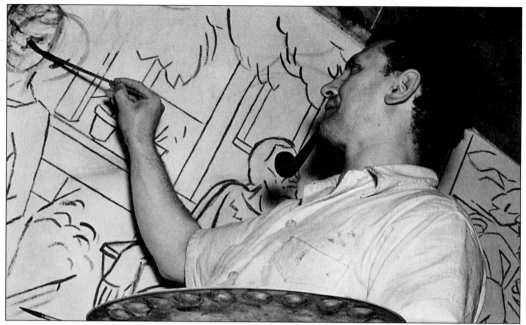

Conrad Albrizio painted murals at Baton Rouge's new capitol, in several post offices in Louisiana and Alabama, in courthouses, and in the New Orleans Union Passenger Terminal. The mural shown here, painted on the north wall of the governor's reception room at the capitol, was later destroyed. He joined the faculty at LSU in 1936, happy for the opportunity to teach young artists. (Courtesy of the State Library of Louisiana.)

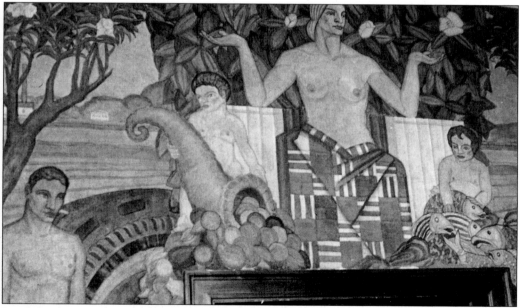

In 1945, John Gasquet, the photographer best known for being the first to take pictures of outlaws Bonnie and Clyde after they were killed, took this picture of Albrizio's mural in the governor's reception room in the capitol. Gasquet worked for the Louisiana state government for many years, and his 4,000 photographs and negatives now reside in the state archives. (Courtesy of the State Library of Louisiana.)

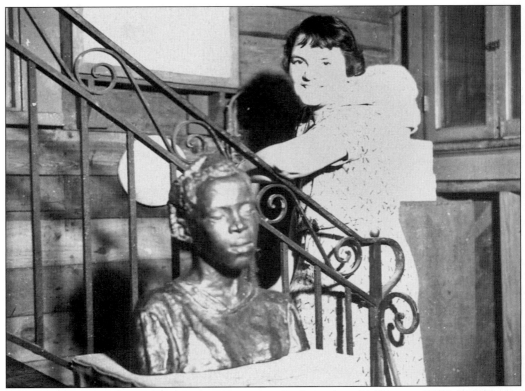

Sculptor Angela Gregory (1903–1990), shown here in her New Orleans studio, created eight bas-relief profiles depicting men who shaped Louisiana to be placed at the entrance to the new state capitol. She also designed the bronze railing that surrounds the relief map on the capitol's floor just inside the building. Her artwork also adorns many structures at LSU. (Courtesy of the Angela Gregory Papers, Tulane University Special Collections.)

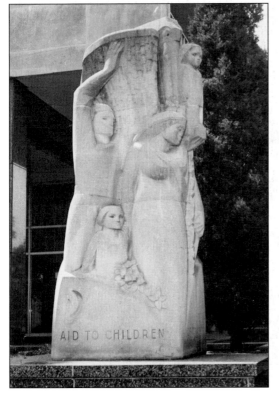

Versatile Italian artist Alfonso Iannelli, known for his paintings, sculptures, and commercial designs, is the creator of *The Welfare Rock* sculpture, shown in front of the Department of Public Welfare at 627 North Fourth Street. The sculpture was retained when the Iberville building replaced the Public Welfare building in 2003. The base reads "Aid to Children." (Courtesy of the State Library of Louisiana.)

Opened in November 1977, the Baton Rouge Centroplex added a large exhibit space and concert hall, as well as this innovative park setting, to the area. The flags of Louisiana, seen in the distance in this image, represent the rule of the French, the British, the Spanish, West Florida, independent Louisiana, the Confederacy, and the United States. (Courtesy of the Louisiana Department of Culture, Recreation, and Tourism.)

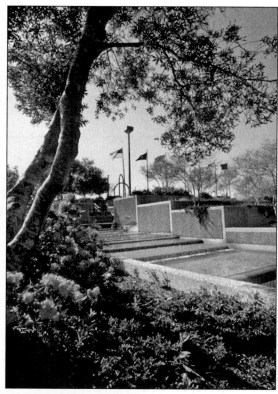

The Shortess Bookshop, opened by Lois F. Shortess in 1938, held a book release party for Robert Tallant, second from left (standing), for his book *Mardi Gras*, published by Doubleday in 1948. Sitting at the table is his friend Caroline Durieux of the LSU art department, who illustrated *Gumbo Ya-Ya*, a 1946 book Tallant cowrote with Lyle Saxon and Edward Dreyer. (Courtesy of the State Library of Louisiana.)

Director Joseph E. Snee (1895–1966) took this image of his Stanocola Refinery Band in 1927 as its members posed in front of the company headquarters building. Part of the Standard Oil Company of Louisiana, the popular band played at many local events. (Courtesy of the J. E. Snee Sr. Photograph Collection, LLMVC, LSU Libraries.)

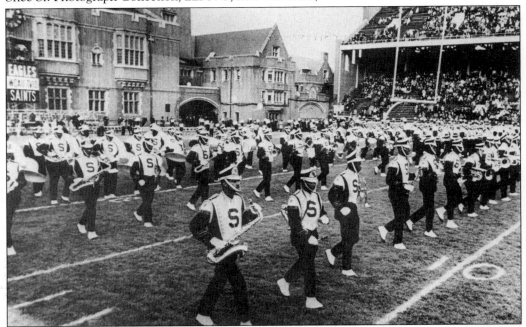

Dubbed the "Human Jukebox," the famous Southern University marching band—one of the best in the world—has appeared in television commercials, at the Rose Bowl parade, at presidential inaugurations, and in Super Bowl halftime shows. The band is shown here at its national television debut, where it played "Sweet Inspiration" and "By the Time I Get to Phoenix." (*The Cat*, Southern University yearbook, 1969, courtesy of LLMVC, LSU Libraries.)

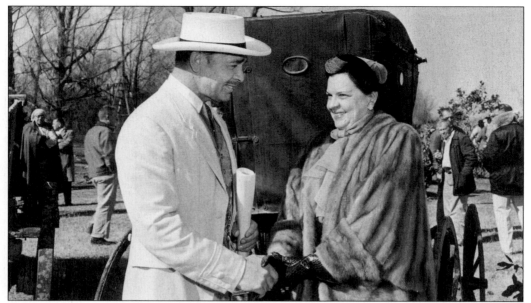

Baton Rouge played host to filmmakers many times over the decades. Here Blanche Revere Long, Gov. Earl Kemp Long's wife, visits with Clark Gable on the set of *Band of Angels*, a 1957 movie filmed near Baton Rouge and based on Robert Penn Warren's novel. During this time, Blanche Long, a politician herself, served on the state's National Democratic Committee. (Courtesy of the Earl K. Long Papers, LLMVC, LSU Libraries.)

In 1966, Baton Rouge welcomed the stars of *Frankie and Johnny*, an Elvis Presley musical, to a party at the old governor's mansion. A police escort led the cars of Donna Douglas, Nancy Kovack, and Sue Ann Langdon. The local people invited to the party hoped to meet Elvis, but he did not attend. (Courtesy of the *Register* Records, LLMVC, LSU Libraries.)

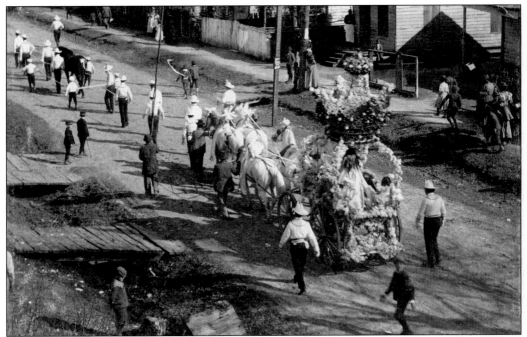

The firemen's parade, a Baton Rouge favorite, rolled through town every year from 1870 to 1914 on February 22, George Washington's birthday. In its heyday, the firemen's parade was more popular than Mardi Gras. This parade, around 1888, marches through the streets of Spanish Town. (Courtesy of the LSU Photograph Collection, RG A5000, University Archives, LSU Libraries.)

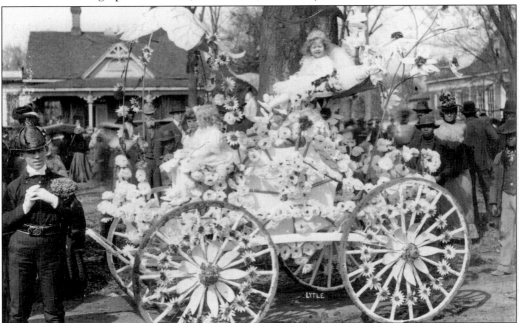

Horse-drawn floats in the firemen's parade were festooned with handmade paper flowers and other decorations. Here daisies line the carriage's wheels, and other blossoms enliven the winter scene as children look down from their high perch. A competition was held for the best floats, with cash prizes for the winners. (Courtesy of the Andrew D. Lytle Collection, LLMVC, LSU Libraries.)

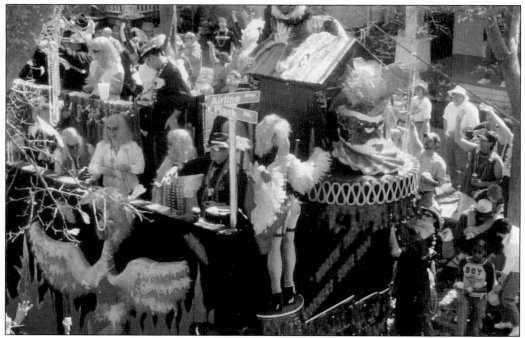

Spanish Town residents started a new Mardi Gras parade in 1981, celebrating their differences from the rest of the city—diversity, kitsch, and irreverence. The parade provides a chance for conservative Baton Rouge to poke fun at state and national politicians, and to party with pink flamingoes. The ladies shown here sport pink wigs as they ride in a parade with the theme "Flamingoes Gone Wild." (Courtesy of Sylvia Frank Rodrigue.)

The annual St. Patrick's Day Parade in Baton Rouge started in the early 1900s and nearly died out in the 1960s. The parade was reborn in the 1980s and is now one of the most popular in the city. The parade-goers shown here on Eugene Street reference the symbol of Spanish Town Mardi Gras with their slogan "Flamingos are Irish Too!" (Courtesy of Sylvia Frank Rodrigue.)

FestForAll, Baton Rouge's festival to celebrate diversity through the arts, began in 1973. Shown here in 1983, Native Americans gather in front of the old Louisiana Department of Insurance building at the corner of North and Fourth Streets under a hot air balloon proclaiming "Louisiana—A Dream State." The festival features food, arts, crafts, music, and performances. (Courtesy of the State Library of Louisiana.)

Southern University athletic director Dick Hill, shown in this July 1984 photograph, lit a festival flame in Catfish Town in honor of the National Sports Festival VI—now called the U.S. Olympic Festival—which took place in Baton Rouge in August 1985. (*State-Times* photograph by Stan Alost/courtesy of Capital City Press, the *Advocate*.)

Seven

1946–2005

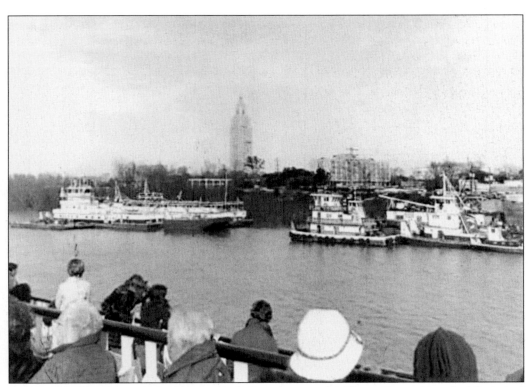

A passenger aboard a tourist boat took this skyline photograph of Baton Rouge from the Mississippi River in the 1970s. The new state capitol can be seen at left, and the old state capitol sits southward, to its right. Tugboats line the shore. (Courtesy of the State Library of Louisiana.)

The State Library of Louisiana was founded in 1920 to create a statewide network of libraries. The downtown library, just south of the capitol on North Fourth Street, contains a vast treasure trove of books, periodicals, manuscript collections, maps, and photographs. Librarians surrounded by card catalogs are shown here in the reference department in the 1940s. (Courtesy of the State Library of Louisiana.)

As the automobile grew in popularity, and as the state's residents grew prosperous enough to afford them, Louisiana established the Bureau of Motor Vehicles (BMV) in 1920. In 1934, William A. Cooper, part owner of the Cooper and Bramer Health Facility, served as director of the BMV. The state employees shown here worked at the modern new BMV office in the 1940s. (Courtesy of the State Library of Louisiana.)

LSU named its new agricultural center, built in 1939 with WPA resources, the John M. Parker Coliseum in honor of the governor called the "Father of the Modern LSU." Among other functions, the Parker coliseum served as the location of graduations until the Assembly Center opened in the 1970s. The farm and tractor show pictured here occurred in the 1950s. (Courtesy of the State Library of Louisiana.)

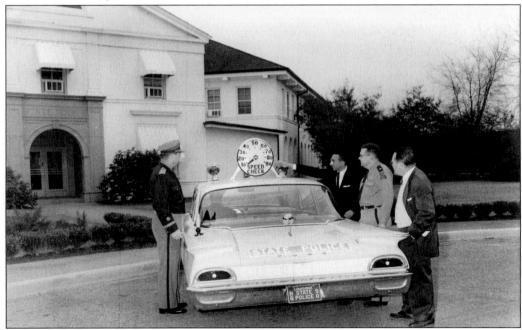

As automobiles became more common in the booming postwar economy, and as more and more roads were built and paved, the Louisiana State Highway Patrol encountered more scofflaws who ignored speed limits. They fought back with aids like this early speed check device. Baton Rouge police acquired the tools in the 1950s after their effectiveness had been proven elsewhere. (Courtesy of the State Library of Louisiana.)

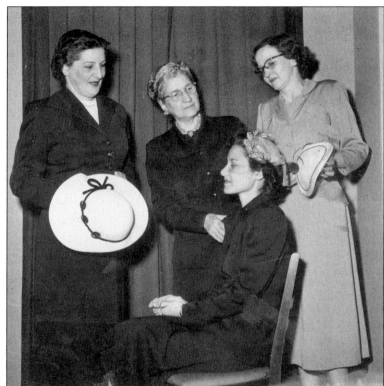

The Baton Rouge Pilot Club, started in 1921, sponsored cancer awareness campaigns and style shows. The shows funded a scholarship for women students at LSU and raised money for children's medical care and other charities. Shown here are 1952 style show models. From left to right are Rene LeBlanc, Cora Baron, Shirley Spindle, and (seated) Sidonie Burns. (Courtesy of the Pilot Club of Baton Rouge Records, LLMVC, LSU Libraries.)

The city's Old Arsenal museum was originally built in the early 19th century to store military supplies, including gunpowder. This replica of the Liberty Bell, installed on July 4, 1950, was part of a national savings bond drive. Its slogan was "Save for Your Independence." The U.S. Treasury Department commissioned 55 bells and shipped them to each state and territory. (Courtesy of the State Library of Louisiana.)

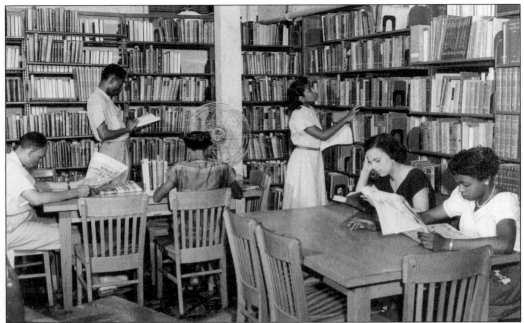

In 1943, the Louisiana state library offered the "Library Service for Colored People," which was quickly renamed the "Negro Reference and Loan Library." Initially, the branch was housed at Southern University, but it moved into the new state library building shown here in downtown Baton Rouge in 1958. By 1964, the Reference Services Division took over the management of this important resource. (Courtesy of the State Library of Louisiana.)

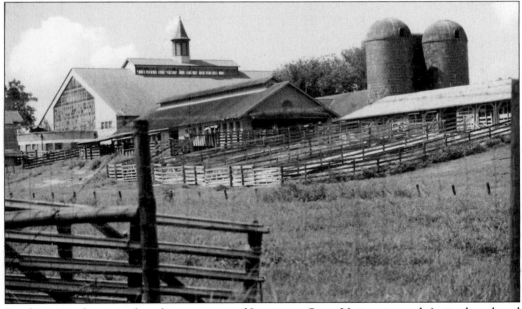

Emphasizing the agricultural component of Louisiana State University and Agricultural and Mechanical College, the building committee for the new campus chose to erect as the first building this 13,000-square-foot dairy barn in 1922. Shown in 1964 surrounded by farmland and silos, the dairy barn served as the training camp for many students studying dairy science. (Courtesy of Art Kleiner.)

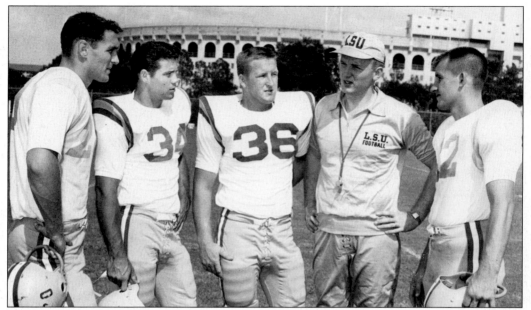

The LSU Tigers football team won its first national football championship in 1958 due primarily to the outstanding skills of All-American halfback Billy Cannon, shown at left with (from left to right) fellow players Johnny Robinson, J. W. Brodnax, coach Paul Dietzel, and Warren Rabb. (Courtesy of the Charles East Papers, LLMVC, LSU Libraries.)

The LSU mascot, Mike the Tiger, has been a fixture on the LSU campus since 1936. Students raised money to purchase the first Mike in 1935; he was kept at the old Baton Rouge zoo at City Park for a year. Shown here in the 1960s is Mike III. Eventually, a lush habitat was built on campus, and today's mascot no longer resides in a cage like this one. (Courtesy of the State Library of Louisiana.)

The eye of Hurricane Betsy moved directly over New Orleans on September 9, 1965, causing tremendous damage. Immediately after the storm passed, Pres. Lyndon B. Johnson flew to the Crescent City to pledge the nation's support. Although Johnson had planned to visit Baton Rouge next, Betsy's effects on the capital city prevented him from doing so. On September 10, Hurricane Betsy's winds were clocked at 58 miles per hour in Baton Rouge. The storm caused a chlorine barge on the Mississippi River to break loose from its moorings, and authorities fought desperately to recover it before the vessel could release its deadly load. This photograph shows unidentified U.S. Army Medical Service personnel as they begin to evacuate patients, including this unidentified man, from local hospitals. Although the barge sank, workers successfully contained the chlorine before it spilled, and the medical service halted its evacuation. In November 1965, workers raised and removed the barge, prompting more closures of area businesses and even LSU until the danger had passed. (Courtesy of the David King Gleason Papers and Photographs, LLMVC, LSU Libraries.)

On Monday, March 28, 1960, seven students from Southern University attempted to integrate the lunch counter in the Kress Department Store on Third Street, shown in the top photograph. Police arrested the students. Baton Rouge police officer J. D. Paul is shown at bottom searching Felton Valdry as officer C. E. Jeffries and Janette Houston Harris watch. The next day, nine other Southern University students staged sit-ins at Sitman's Drug Store and the Greyhound Bus Station. Although the students arrested at Kress made bail, thanks to assistance from the community, Southern expelled them, sparking a boycott of classes. The university later readmitted 12 of the 16 students. (Above *Advocate* photograph by Travis Spradling/courtesy of Capital City Press, the *Advocate*; below *Advocate* photograph by John Boss/courtesy of Capital City Press, the *Advocate*.)

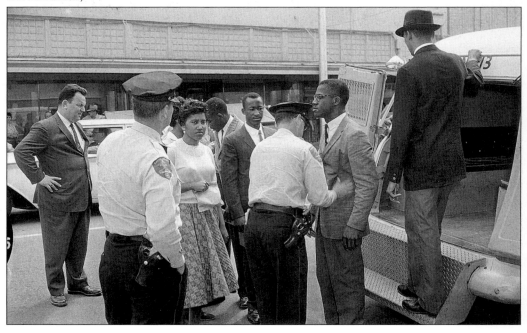

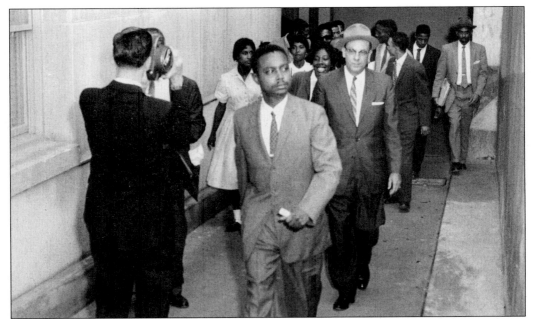

This photograph shows Vernon Jo Jordan on April 4, 1960, as he leads the newly released Southern University students to their waiting families and friends. The students walking behind him had been arrested the week before for disturbing the peace at Sitman's Drug Store and the bus terminal. At the far right is attorney Johnnie Jones. (*State-Times* photograph by John Boss/courtesy of Capital City Press, the *Advocate*.)

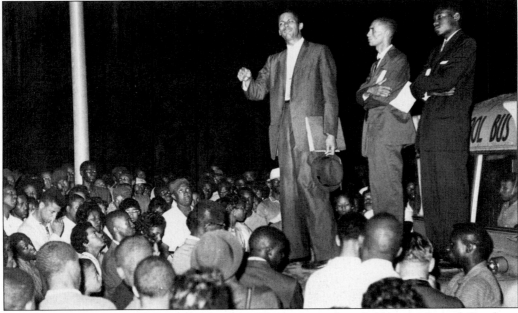

On April 1, 1960, eight of the expelled Southern University students held long talks with Southern University officials. From left to right, Donald Moss, Marvin Robinson, and Major Johns speak around midnight to the 3,000 students awaiting the outcome. The expelled students announced that they wanted the protest to end and urged fellow students at Southern University to cancel a walkout. (*Advocate* staff photograph/courtesy of Capital City Press, the *Advocate*.)

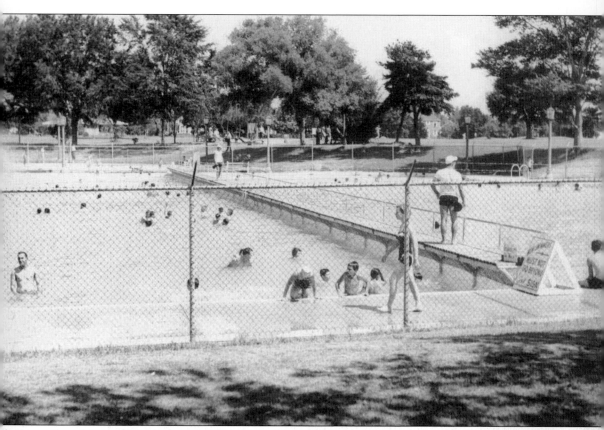

The whites-only swimming pool at Baton Rouge's City Park, shown here in 1960, was a popular gathering spot for many years. The 160-acre park opened in 1923 and originally featured this pool and a clubhouse, a zoo, a baseball stadium, and a carousel. In 1963, five young African Americans, including Betty Claiborne and Pearl George, attempted to integrate the pool but were arrested for their efforts. Prosecutors convicted both women, and they each served time in jail. Similar protests occurred in other Southern cities, and in 1964, the U.S. Supreme Court ruled it unconstitutional to segregate park facilities. Rather than integrate the pools and pool houses, Baton Rouge closed its nine public swimming facilities. The following year, local residents marched from the closed pool to the downtown area, seeking the reopening and desegregation of the pools. Five reopened, but the city filled this pool at City Park with concrete. (Courtesy of the *Register* Records, LLMVC, LSU Libraries.)

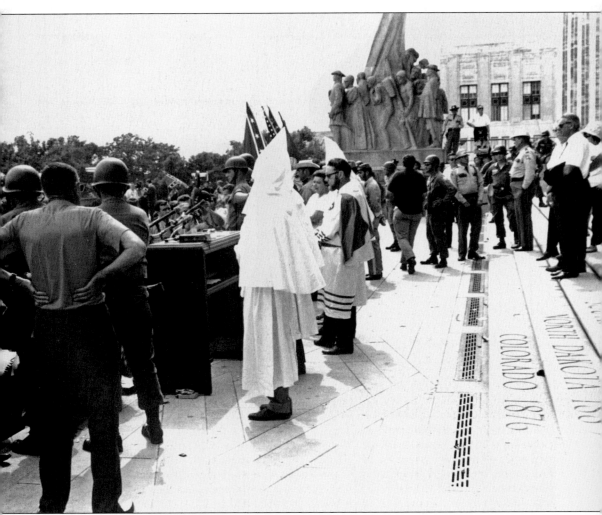

Although the civil rights era did not bring the same amount of violence to Baton Rouge as it did to some Southern cities—Baton Rouge public high schools, for example, integrated without riots in September 1963—interracial tension was high in the city and the state. In August 1967, World War II veteran and labor organizer Albert Zekel (A. Z.) Young led a 10-day march from Bogalusa to Baton Rouge along U.S. 190 to protest racial discrimination and violence. The marchers were accompanied by 175 state troopers and some 650 National Guardsmen to keep jeering crowds from attacking them. The Ku Klux Klan planned a counter protest at the state capitol, hoping to reach it when the marchers arrived. They were a day late: the marchers reached the capitol's steps on August 19, but the KKK rally (shown here) occurred on August 20. Only 50 Klan members came to the protest. The event proceeded without violence, though someone accidentally discharged tear gas. (Courtesy of the State Library of Louisiana.)

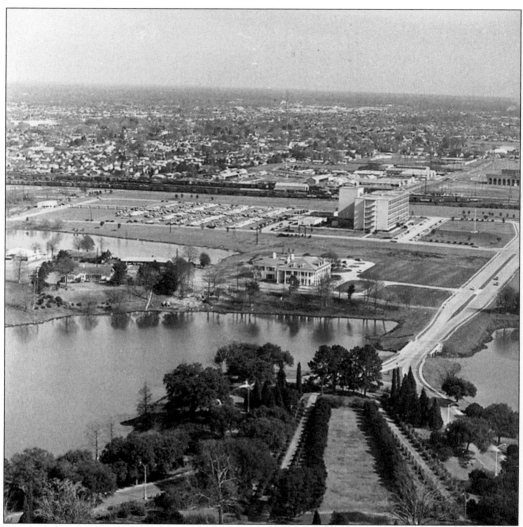

Across Capitol Lake, the new governor's mansion, completed in 1963, can be seen in the center of this 1960s aerial view of northeast Baton Rouge, likely taken from the top of the capitol. The tall building behind the mansion is the Louisiana Department of Transportation and Development. In the distance at right is the Baton Rouge Parks and Recreation Commission (BREC)'s Memorial Stadium, used for a variety of high school sports by many local schools, as well as for concerts and other events, such as monster-truck rallies. Memorial Stadium, built in 1956, was erected in honor of the members of the military who fought in World Wars I and II and in Korea. Today the stadium is bordered by railroad tracks, Foss Street, Scenic Highway, and Interstate 110. A small neighborhood of exclusive homes is shown at left near the mansion. (Courtesy of the State Library of Louisiana.)

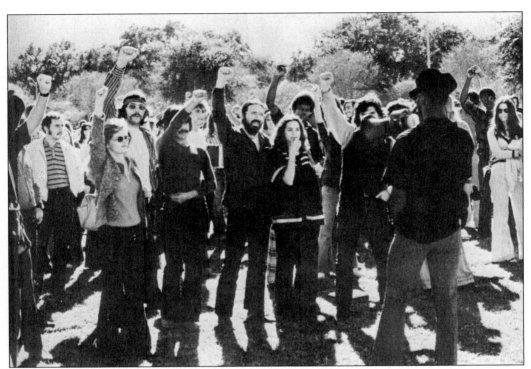

In 1971, the LSU students shown here rally on the parade grounds before staging an anti–Vietnam War sit-in at LSU chancellor Cecil "Pete" Taylor's office. Leo C. Hamilton, an African American civil rights attorney in Baton Rouge who attended undergraduate and law school at LSU, took part in the protest. (*Gumbo* Yearbook, 1971, courtesy of LLMVC, LSU Libraries.)

The Prince Hall Masonic Temple on North Boulevard, a popular venue for African Americans, boasted a theater as well as the famed Temple Roof Garden, the site of many wedding receptions and performances by Louis Armstrong, Ella Fitzgerald, and others. In 1972, however, it was the site of a race riot in which four people were killed. (*Advocate* staff photograph/courtesy of Capital City Press, the *Advocate*.)

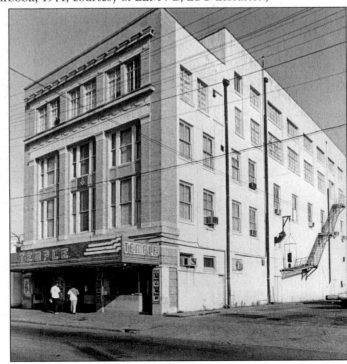

For most of his career, architect A. Hays Town, pictured here around 1970 with his wife, Blanche Scharff Town, took what work he could, designing commercial buildings, shopping centers, churches, and schools. Eventually, he was able to focus solely on his main interest, residential housing. Town, who lived to be 101 years old, made a lasting impact on south Louisiana architecture. (Courtesy of the *Register* Records, LLMVC, LSU Libraries.)

The courtyard of the Tri Delta sorority house at LSU shows the relaxed, inviting quality of Town's buildings. His residential designs beautifully incorporated Acadian, Spanish, French, and Creole influences to create a distinct south Louisiana style. He was known for extraordinary attention to detail, reclaiming discarded building materials, and encouraging the use of design to counteract the discomforts of long Louisiana summers. (Courtesy of Delta Delta Delta sorority, LSU.)

Construction expert W. Hamilton Crawford helped to fill the national postwar need for modern, affordable housing by manufacturing sturdy prefabricated homes and by designing pleasant, beautifully landscaped housing developments. He lived in Baton Rouge in a two-story house on Country Club Drive, and he was known for using the same type of building materials in his own home as those he used in the homes of his customers. The Crawford house pictured here, in the city's appealing Westdale Terrace neighborhood, was built in 1955 for Ralph Sims, a war hero who fought as a tail gunner in a B-17 bomber. Sims earned three Air Medals and a Distinguished Flying Cross. He worked for the radio station WJBO before the war and returned to his old company afterward, but eventually he went to work in the marketing department of the Crawford Corporation. (Courtesy of Tom Bartkiewicz.)

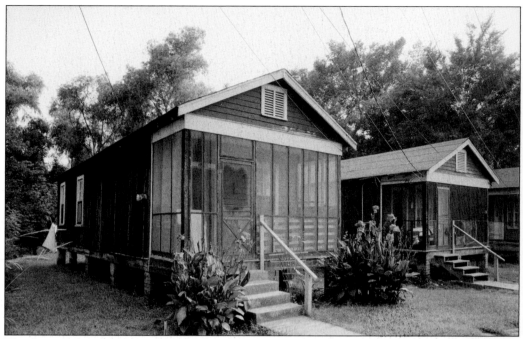

The shotgun home, a form of architecture popular in urban areas of Louisiana, may have its roots in Africa or the Caribbean. These long, narrow houses can be found in many parts of Baton Rouge. The homes shown here in the 1970s are on Gayosa Street in Spanish Town. (Courtesy of the Library of Congress.)

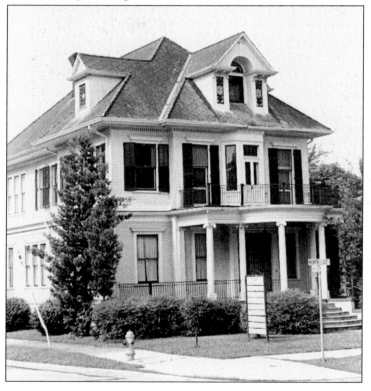

This restrained Queen Anne–style house, shown in the 1970s, represents Baton Rouge's Beauregard Town, an early subdivision that Elias Beauregard designed on his land in 1806. Government Street, then named Calle del Gobierno, divided the area in two. The entire subdivision is now on the National Register of Historic Places. (Courtesy of the Louisiana Department of Culture, Recreation, and Tourism.)

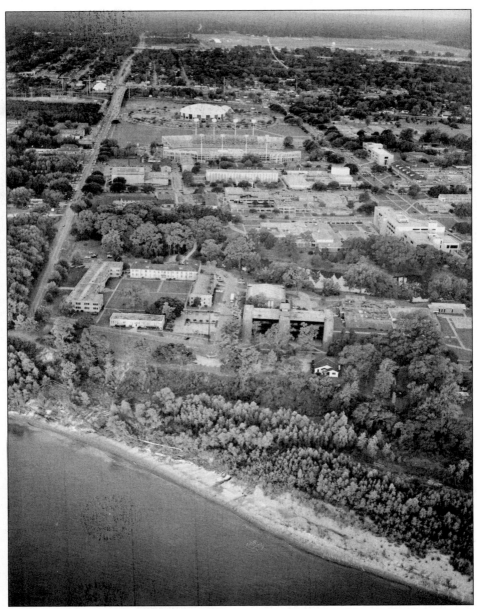

Established in 1879 and opened in New Orleans in 1880, Southern University and Agricultural and Mechanical College relocated to Baton Rouge in 1914. Southern sits atop beautiful Scott's Bluff along the Mississippi River, as shown in this sky view taken by David Gleason in the late 1980s, and is the main campus of the largest historically black college and university system in the United States. This photograph shows Harding Boulevard at right. The domed building in the rear center is the Felton G. Clark Activity Center, named for the second president of the Baton Rouge campus; his father, Joseph Samuel Clark, was the first. Mumford Stadium—home of the Jaguars—lies in front of the activity center and was named for legendary football coach Arnett W. "Ace" Mumford. Academic buildings and dormitories lie between the football stadium and the Mississippi. Between the buildings and the river, Frank Hayden's memorial sculpture of a red stick sits approximately where explorers spotted the original red stick that gave Baton Rouge its name. (Courtesy of the David King Gleason Papers and Photographs, LLMVC, LSU Libraries.)

Pinkie Gordon Lane, Louisiana's first African American poet laureate, is shown here (first row, fourth from the right) with her colleagues in 1985, when she served as head of the English department at Southern University. Lane earned her doctorate at LSU and went on to teach at Leland College and Southern University. (Courtesy of the Pinkie Gordon Lane Papers, LLMVC, LSU Libraries.)

Nelson Mandela (center) visited Baton Rouge on May 11, 2000, and gave a talk at a banquet hosted by the city's two universities. Shown with him are, from left to right, Southern University president Leon R. Tarver II; his wife, Cynthia Tarver; Peggy Jenkins; and her husband, LSU system president William Jenkins. (*Advocate* photograph by Arthur D. Lauck/courtesy of Capital City Press, the *Advocate*.)

Opening in 1968 and shown here soon afterward, Woman's Hospital—formed to improve the health of women and infants in the Baton Rouge area—was one of the nation's first hospitals to specialize in women's health. The facility, which is at the corner of Airline Highway and Goodwood Boulevard, excels at obstetrical and neonatal care. (Courtesy of the David King Gleason Papers and Photographs, LLMVC, LSU Libraries.)

Explorer Pierre Le Moyne, Sieur d'Iberville, commented on the beauty of the lush Spanish Lake Basin when he traveled the Baton Rouge area in 1699. The basin, home to abundant wildlife and giant bald cypress trees, is accessible through Alligator Bayou in the eastern part of the city. (Courtesy of the Louisiana Department of Culture, Recreation, and Tourism.)

In this summer 1982 photograph, the *Mississippi Queen*, a re-creation of an 1850s steamboat, and World War II battleship USS *Kidd* are shown together in front of the Interstate 10 bridge. Vacationers took river cruises on the *Queen*, built in 1976. Now a tourist attraction, the *Kidd* was named after Isaac C. Kidd Sr., a sailor killed at Pearl Harbor. (Courtesy of the Louisiana Department of Culture, Recreation, and Tourism.)

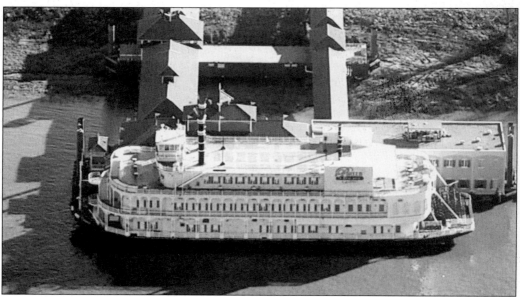

In 1992, Louisiana legalized riverboat casinos to bring in new revenue, and the *Belle of Baton Rouge* was the city's first. It is docked near Catfish Town, once home to much of the city's African American population. The second riverboat, *Hollywood Casino Baton Rogue*, is docked near Capitol Lake. (*Advocate* photograph by Richard Alana Hannon/courtesy of Capital City Press, the *Advocate*.)

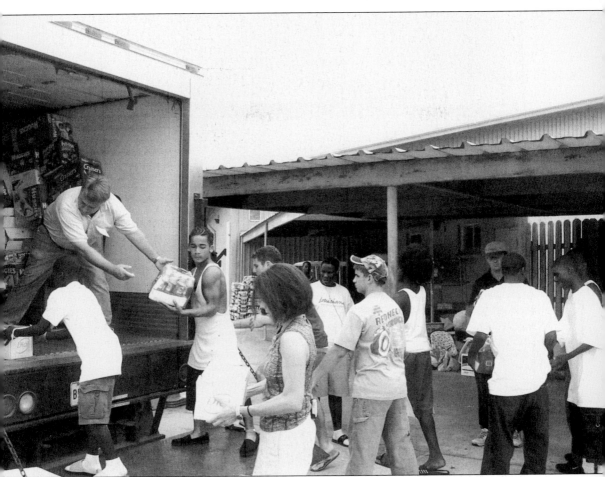

On August 29, 2005, Hurricane Katrina whipped through Louisiana and Mississippi. In New Orleans, floodwaters inundated the Ninth Ward and other neighborhoods. Due to a storm surge and the failure of the levees, about 80 percent of the Crescent City was under water. After shaking off the storm's limited effects—mainly downed trees and power lines—Baton Rouge welcomed hundreds of thousands of newcomers and became the staging ground for rescue and relief efforts. Federal Emergency Management Agency (FEMA) relief workers took over BREC's Memorial Stadium on Foss Street. The universities provided emergency housing and took in students from New Orleans. Evacuees who needed medical care stayed at LSU's Maddox Field House and the Maravich Assembly Center. Others stayed with family and friends, at churches and schools, and at the downtown River Center. The LSU School of Veterinary Medicine cared for rescued pets at the Parker Coliseum. In one outstanding effort, shown here, volunteers for the Greater Baton Rouge Food Bank collected supplies for New Orleanians and evacuees. Many of the evacuees stayed at Baton Rouge–area shelters for months. (Courtesy of the Greater Baton Rouge Food Bank.)

BIBLIOGRAPHY

Carleton, Mark T. *River Capital: An Illustrated History of Baton Rouge*. Revised ed. Tarzana, CA: American Historical Press, 1996.

Dawson, James G. III, ed. *The Louisiana Governors: From Iberville to Edwards*. Baton Rouge, LA: LSU Press, 1990.

Gleason, David King. *Baton Rouge*. Baton Rouge, LA: LSU Press, 1991.

Kingsley, Karen. *Buildings of Louisiana*. New York: Oxford University Press, 2003.

Poesch, Jessie, and Barbara SoRelle Bacot, eds. *Louisiana Buildings, 1720–1940: The Historic America Buildings Survey*. Baton Rouge, LA: LSU Press, 1997.

Rodrigue, Sylvia Frank, and Faye Phillips. *Historic Baton Rouge*. San Antonio, TX: Historical Publishing Network, 2006.

Ruffin, Thomas F. *Under Stately Oaks: A Pictorial History of LSU*. Baton Rouge: LSU Press, 2002.

Vetter, Cyril E. and Philip Gould. *The Louisiana Houses of A. Hays Town*. Baton Rouge, LA: LSU Press, 1999.

Vincent, Charles. *A Centennial History of Southern University and A&M College, 1880–1980*. Baton Rouge, LA: Southern University, 1981.

INDEX

ACROSS AMERICA, PEOPLE ARE DISCOVERING SOMETHING WONDERFUL. *THEIR HERITAGE.*

Arcadia Publishing is the leading local history publisher in the United States. With more than 4,000 titles in print and hundreds of new titles released every year, Arcadia has extensive specialized experience chronicling the history of communities and celebrating America's hidden stories, bringing to life the people, places, and events from the past. To discover the history of other communities across the nation, please visit:

www.arcadiapublishing.com

Customized search tools allow you to find regional history books about the town where you grew up, the cities where your friends and family live, the town where your parents met, or even that retirement spot you've been dreaming about.